The
PHOTOGUIDE
to
Colour

THE (f) PHOTOGUIDES

The PHOTOGUIDE to Colour

David Lynch

Focal Press
London & New York

ISBN 0 240 50921 8

First edition 1976
Second impression 1977
Third impression 1978

Text set in 10/11 pt. Photon Univers, printed by photolithography and bound in Great Britain at The Pitman Press, Bath

Contents

Why are
You Reading
this Book?

Was it idle curiosity which made you pick it off a shelf which is probably packed to capacity with books on photography? Perhaps the illustration on the cover attracted you and decided you to flip through the pages. Or . . . was it that you already take pictures in black and white and are just a little bit dissatisfied with the results.

Maybe you don't take pictures very often, just the odd one here and there when you go on holiday. Perhaps when you see the results, however sharp and clear they may be, they leave you with the feeling that there is something missing. They're a record of your holiday certainly, but hardly a complete record. Holidays are fun, excitement, gaiety and, most of all, colour. You can capture everything on your black-and-white film except that most vital ingredient of all — the colour.

Possibly, on the other hand, you are an enthusiast, interested in photography as a means of making pictures rather than merely records. Perhaps you feel you have gone just about as far as you wish to go in monochrome and now you would like to take that vital step forward into the world of colour. Alternatively, perhaps, you do take a few colour pictures; but feel you could do better. This book can help you explore the possibilities; and make the most of colour photography.

Whichever you are — discontented holiday snapper or cautious enthusiast — this book is to help you. If you haven't used colour, you have to make a change, which is always difficult. Even if you take the odd colour film, there are so many arguments against colour photography. Colour photography is difficult; colour photography is expensive; who needs colour anyway? The point is, are the arguments fact or fiction? Are the evils real or imagined? In this first chapter we hope to give you the answers to these questions. We hope to show you the value and simplicity of modern colour photography. Then, when we have done that, we want to show how you, too, can take colour pictures successfully; and how you can avoid the pitfalls which are waiting to trap the unwary. In later chapters we will go on to tell you how you can make really satisfying pictures in colour. You can do it and you can do it easily.

So, whether you are old hand or novice, happy-snapper or pensive picture-maker, if you would like to make the transition from a world of grey to a world of myriad hues; or if you just want to improve

your colour photography; then read on. We will help you to do so, we hope, without you having to waste a single picture.

Ready? Then let's go.

Do you need colour?

First of all, let's consider why you should be dissatisfied with black-and-white pictures. They may well have satisfied you up to now: but that is no reason not to progress to something better and more satisfying. Nobody who is creative or intelligent can be satisfied with the status quo for long. It is too much a part of our nature to want to progress – conquer fresh fields.

Black-and-white pictures form an acceptable record – of the scene in front of the camera: well, fine if all you want is a "just acceptable" record. Most of us, however, even if we are only occasional snapshotters, wish to produce something more than that. This, in turn, leads us to the question, do black-and-white pictures even produce an acceptable record? How can they when they leave out one of the most important elements of any scene – the colour. According to dictionary definition, to "record" is to set down for remembrance or reference. Surely then, any picture which has pretensions to being a record *must* be in colour.

Why are we so preoccupied with colour? Purely and simply because colour is so much a part of our lives. Have you ever thought what it might be like to be colour blind? Not colour blind in the accepted sense where one is unable to distinguish between red and green but *really* and *totally* colour blind – incapable of seeing any colour at all. Just think for a moment. Think about Spring, with soft, grey blossom outlined against a grey, springtime sky; think about lambs playing on the fresh, grey grass; children in their grey dresses picking little, grey buttercups; no colour at all – isn't that a chilling thought. Even if we take the dullest, most mundane scene imaginable, somewhere buried in it we will find colour; perhaps a subtle juxtaposition of complementing hues, or a tiny speck of colour that brings it all to life. Why then, when we think about taking pictures, do so many of us reach for a black-and-white film and set about taking pictures which are, in the truest sense of the word, colour blind?

13

Colour is everywhere

Everywhere we look there is colour. Often we tend not to notice it simply because we are so used to it. Take, for instance, a misty day in autumn. The greens and gold take on an almost ethereal quality as a shaft of sunlight filters through the haze. What a picture it would make in colour, but how much would be lost if it were not. Look closely at a rose, really seeing the subtle variations in hue in a single flower. We can show these variations in colour, but in monochrome we haven't a chance. Picture the sea-front on a sunny day in summer. Brilliantly coloured stalls, golden sands, blue sky and blue sea and everywhere, people in holiday mood. In colour, it's all there; the life, the soul, the gaiety and the sunshine. In black-and-white — why we are colour blind again.

Nowadays, we are becoming much more aware of colour, learning about it and putting it to work for us. It shows in our furnishings, in the decoration of our homes and in the clothes that we wear. Our homes are decorated with paints and wallpapers which, twenty years ago, would have been considered outrageous. On our walls we hang posters and post-impressionists — contrasts in flamboyance and subtlety. Our furnishing fabrics range from the most delicate of pastel tints to the wildest of psychedelic nightmares. Take a stroll down a busy shopping street. On the greyest of days it will be a blaze of colour; with brilliantly lit shop fronts, brash advertisements, flashing car enamels and a rainbow of brightly-coloured clothes. Even the once-sombre business man wears a rose-pink shirt and a suit the most delicate shade of mauve.

Our photographs serve as our memories. They recall the happy times and the wonderful times. The times we will look back on with nostalgia. They recall tender moments; children growing up, the good times and the not-so-good times. And none of it happened in black-and-white.

Colour is easy

There is probably one question which, more than any other, troubles the photographer who would otherwise turn to colour like a shot. Isn't

it difficult? The short answer to that one is – no. Admittedly, you will find books and experts, all anxious to tell you just how complicated it is, but take no notice. Similar Jonahs exist in all walks of life and they just enjoy making simple things complicated.

Making pictures in colour is easy, and you can prove it by loading a colour film into your camera and taking a few snapshots. If you have any doubts at all, walk down to your local chemist shop and have a look at the stock of film on his shelves. Almost certainly there will be far more colour film than black-and-white; and you can be sure there are not *that* many experts in your district. Look, too at the display of inexpensive camera outfits on the counter. Packed with everyone you will find a colour film. These outfits are for sale to people whose photographic knowledge is just about zero. People who buy these cameras, with no experience of photography, expect to take that camera out of its wrapping, load it with the colour film and go out and take perfect colour pictures. Well, perhaps they won't produce perfect pictures, but they can produce jolly good ones. If they can do it, you can too.

Taking pictures in colour is just as easy as taking pictures in black-and-white, and far more rewarding. If you can do one you can do the other. If you have produced black-and-white pictures without too much effort, then you will certainly experience no problems producing colour pictures. If you *do* have problems, then it won't be because colour is difficult. It will be because somewhere along the line you are making a simple mistake. You can probably put this right very quickly by re-reading your camera instruction booklet or the instruction leaflet packed with the film.

Of course, as you gain experience you become more skilled in using colour materials. You can then become more adventurous and tackle subjects which are more demanding technically. Anybody lucky enough to have such ingredients available as a beach, sunshine, a pretty girl and a camera loaded with colour film can hardly fail to produce a good result. A portrait, indoors, however, with artificial light, needs a lot more care and knowledge; but there is no reason why, even at the beginning you still should not produce excellent results. The secret is in learning as you go along. Like every other craft, the rewards are in direct proportion to the amount of effort you make. If you are prepared to spend time reading, learning and above

all, experimenting — trying out new techniques — you will get more pleasure from your photography and much more exciting and rewarding results. It isn't difficult, it's fun. It can be hard work, but the rewards can be terrific. Best of all you can enjoy it at your own pace. You don't *have* to do anything other than put a film into your camera and take pictures. Where you go from there is up to you.

Colour isn't expensive

In these days of constantly-rising prices, everything we enjoy doing (and even a good deal of what we don't enjoy) seems to cost more and more money. What, then, are the facts about colour photography. Are you going to have to spend a lot of your hard-earned cash on it? Is it going to prove an expensive pastime?

The pleasant thing about making pictures in colour is that it can be just as expensive or just as inexpensive as you want it to be. The deciding factor is how much you want to spend. If you are in the enviable position of having a fair bit of cash to play with at the end of every month, you can reel film through your camera like lemons through a fruit machine. On the other hand, if it takes most of your pay packet to feed the family dog, don't get too down-hearted. The occasional picture can amply compensate for the cup of tea you went without to pay for it.

Colour pictures don't give a transient pleasure which is here one moment and gone the next. The chap who said "A thing of beauty is a joy forever" was right. If we make a picture which is good and which pleases us, it will please us not only the first time we view it, but the next time, and the next time and the next time. What is more, it will give other people pleasure too. Pictures can almost be looked upon as a form of investment, the value of which grows as the years wear on. You may not place a terribly high value on that picture of your 14-month old daughter taking her first steps now, but in twenty years time

To get down to facts, however. The first item you are going to need is a camera. If you have one already you've saved yourself some money. If you don't have one then you'll need to spend some. Not necessarily a lot, though. In the next chapter, we will discuss cameras and give

you some ideas regarding inexpensive types which are quite capable of taking very good pictures.

Once you have a camera your only outgoings need to be on film and processing. A camera without film is just like a car without petrol — useless. Film is less costly than petrol but just as you don't waste the petrol you put in your car, you certainly won't want to waste the film you put in your camera. If you think carefully before taking pictures and plan ahead as much as possible, you fill find that you obtain better pictures with less wastage of film. Better to ensure that everything in the picture is right *before* you squeeze the shutter release, than realise you have to make some alterations *after* you have wasted a shot. Shooting first and asking questions afterwards is a good technique when you have no time to think, but it can lead to an awful lot of spoiled pictures under normal circumstances.

Let's have a look at a few facts which may give you some idea of the relative costs of making pictures in colour:

> You can buy a camera which will enable you to take very good colour photographs in a variety of situations for the price of two or three long-playing records.
>
> A "system" camera which will give you almost unlimited picture-taking potential need cost little more than a good portable radio.
>
> The price of a round of drinks will purchase a 36-exposure colour film.
>
> A colour enlargement suitable for your mantlepiece can cost less than a box of chocolates.

As we said before, nothing is cheap these days, but you must weigh against your outgoings the amount of pleasure you are going to get from your hobby.

A final point, while we are on the subject of cost, is something which might come under the heading of a hidden extra. You may decide that you are going to make colour transparencies rather than colour prints because the cost is apparently less. It is, in fact, less but don't forget you are going to need something to view your transparencies with — a viewer or a projector. A viewer is cheaper but a projector can be a better long-term investment and reasonable models can be bought for less than the cost of about four or five long-playing records.

The choice is yours. Can you afford *not* to take pictures in colour?

The
Basic
Essentials

Before you can take any sort of picture, colour or black-and-white, good or indifferent, you need two things – a camera and a film. These are the basic essentials. All the accessories, gadgets and odds and ends which supposedly help you make better pictures will come later. The trouble is, there are an awful lot of cameras to choose from and there is even a pretty wide selection of films. Which camera should you buy and which film is going to be right for you? Everybody is different and what is right for one person may not suit another. However, we can give some facts about cameras and films which should put you on the road to choosing the best one for your purposes.

Which Camera?

Cameras come in all shapes and sizes and can vary in price from the phenomenally expensive to the, apparently, ridiculously cheap. The camera you use and the way you use it will, to some extent, determine the sort of pictures you are likely to achieve.

Perhaps you already have a camera. If you have, then that's good – particularly if it is a fairly simple one without complicated controls and gadgets. While you are finding your feet, the fewer complications you have to worry about the more you can concentrate on making worthwhile pictures. If you already have a simple camera, then, provided it is in good condition, stick with it until you can produce a good picture every time. Recognise its limitations and work within them. Then, when you are really confident, go on to more complex, precision equipment.

If you haven't got a camera, then you need to think about obtaining one – and this is where you can run into your first difficulty. Camera shops and discount warehouses all over the country are just bursting to sell you a camera. Everywhere you look, in every advertisement and in every dealer's window you will find large cameras and small cameras, reflex or rangefinder and each one proclaiming that it and it alone is the one that is going to solve all your problems. You can hand over all your life savings, re-mortgage your house for the camera of your dreams, only to find that you own an instrument which is just as capable of turning out bad pictures as the antique box camera the

dealer refused to take in part exchange. What do you do?

Unless you are already a confident, practising photographer capable of handling a sophisticated camera rapidly and easily – the most sensible thing to do is to buy a simple camera. One which is easy to use and has no hidden complexities for you to forget to operate. Learning to use a camera properly is a little bit like learning to drive a car (but not half so dangerous). If you had never driven a car before, you certainly wouldn't go out and buy a Ferrari, would you? In the same way, it's not a good idea to go out and purchase a complex piece of photographic equipment when you're just learning how to take pictures. At this stage, let us look closer at what a camera is and how it works.

The vital constituents

Fundamentally, any camera is a lightproof box which holds the film and the various bits and pieces together. It has a lens at one end which focuses a beam of light from the subject on to the film. At the other end is a compartment to hold the film. Close to or within the lens is an aperture, or diaphragm, which limits the size of the beam of light entering. A shutter prevents light from reaching the film except at the moment of exposure. A camera also has a viewfinder through which the subject is sighted.

Let's take a look at the essential parts separately:

The lens in its simplest form is a piece of glass, or plastic, shaped to collect light rays coming from the subject. It brings these light rays to a focus on the film to form an image. Remember how you used to focus the suns rays through a magnifying glass on to a sheet of paper? The principle is just the same, only in this case the film doesn't go up in smoke. It records a picture, instead.

The simple camera has a single lens, probably moulded in plastic; set in a fixed position so that everything more than about five feet away always comes out, *reasonably* sharply in the picture. Only a small area at the centre of the lens is used, so only a small amount of the light from your subject gets through to the film. This means that you can take pictures only of well-lit subjects – either in fairly bright sun, or with flash.

At the other end of the scale, a precision camera has a much more complex lens, probably made up of four or more individual lenses (called elements). Each element is ground to very fine tolerances and they are all fitted together extremely accurately. The lens can be moved towards or away from the film to alter the focus. Any object between, say, twenty inches from the film and infinity can be recorded sharply. Complex lenses are made so that light can pass through quite a large area of glass. This means that much more light can pass through it and you can take pictures in quite poor lighting conditions.

Some cameras are made so that you can take off the whole lens and replace it with a different one. You may want to use an even larger lens to let in more light, or one which can be focused on closer objects, but the main reason for changing the lens is to fit a wide-angle unit to take in a wider field, or a long focus (telephoto) lens to make distant objects come out larger. *The diaphragm* controls the light that gets through the lens. Every lens allows a certain amount of light to pass through it and, all other things being equal, the larger the lens, the more light which will pass through it.

However, with a fairly large lens, you won't always want to use all the light the lens will pass. A film requires only a certain amount of light to expose it properly. Too much light and it will be *over*-exposed: too little light and it will be *under*-exposed. Both faults produce poor quality or even lost images; and, in colour, there is no way you can compensate for exposure errors. Therefore, because there are dull days and sunny days, you need to be able to control the amount of light passing through the lens. A simple camera has a fixed aperture (or hole) behind the lens, so that on a sunny day just the right amount of light gets through. This means that on a dull day, or in poor lighting conditions, your picture will be under-exposed unless you use flash. On more complex cameras, an adustable aperture, or diaphragm is fitted, which allows you to control exactly the amount of light falling on the film. It is simply a mechanism for providing a variable sized hole (aperture). The camera is marked to show you what size hole you are setting. How this affects exposure is discussed on page 45. Conventional diaphragms are marked in *f*-stops. These are calculated so that (within normal tolerences) they represent the light-passing ability of each setting. Almost all modern lenses are calibrated on the scale:-

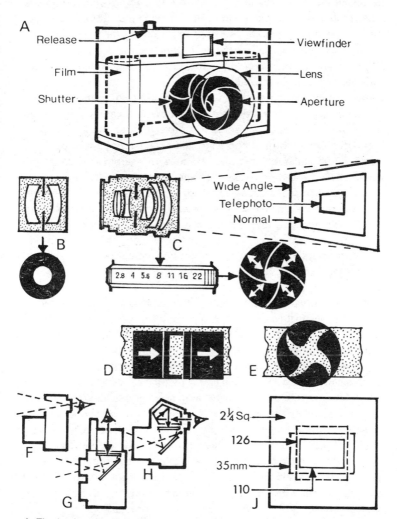

A. The basic essentials of a camera. B. Simple lens with fixed, single aperture. C. More complex lens with variable diaphragm. D. Focal-plane shutter. E. Diaphragm shutter. F. Simple direct vision viewfinder. G. Twin lens reflex viewfinder. H. Single lens reflex viewfinder. J. The common film sizes.

1, 1.4, 2, 2.8, 4, 5.6, 8, 11, 16, 22, 32, . . . These figures represent the ratio of the distance the lens is from the film to the diameter of the hole. Each larger number indicates a halving in the light reaching the film (because the area of the hole determines the light that gets through). Each step is calculated by multiplying the one before by $\sqrt{2}$. Although most lenses use this scale, often their maximum aperture falls between two of the calibrations.

As well as controlling the quantity of light passing through the lens, the diaphragm, to some extent, also controls the sharpness of the image. When you focus your subject sharply through the lens, objects some distance in front of and some distance beyond the subject are also recorded tolerably sharply. This area of sharpness is called the *depth of field* and it generally increases as lens aperture decreases. Depth of field also increases as the lens is focused on objects farther from the camera. One of the reasons why a small aperture is used in a simple camera is to give a large depth-of-field, so eliminating the need for focusing.

The shutter lets the light reach the film only when you want it to, and controls the amount of time for which light is allowed to fall on the film.

In early days of photography, when photographic materials were slow and not very sensitive to light, exposure times of up to half-an-hour were not uncommon. Nowadays, films are much more sensitive and exposure times are generally in the region of $1/30 - 1/500$ second which, when you think about it, is a very short time indeed.

Simple cameras usually have a shutter which operates only at one or two fairly low speeds. It is just a leaf or vane which, when at rest, covers the lens. When the shutter is released, a spring pushes the leaf aside for a short time, letting light pass through the lens and fall on the film. This exposure usually lasts for about $1/40 - 1/50$ second.

Rather a different kettle of fish are the shutters to be found on precision cameras. There are two basic types: focal plane shutters (which are usually found on interchangeable lens cameras) and diaphragm shutters (which are to be found on most other types).

A focal plane shutter sits just in front of the surface of the film. The older type consists of two roller blinds (like those you see on some windows). At rest, one of these blinds completely covers the film, protecting it from the light. When you make the exposure, the first

blind is released and passes rapidly across the surface of the film, un-covering it. Almost immediately, the second blind follows. Most newer designs of focal plane shutter work on the same principle, but use folding metal blinds which travel vertically across the film. A range of exposure times lasting from 1 second to $1/1000$ second is frequently found on cameras with focal plane shutters.

Diaphragm shutters are usually fitted between the elements of a lens. They consist of a ring of inter-leaving blades, pivoted at their outer edge. When the shutter is released the blades spring apart, outwards, rather like a diaphragm, leaving a hole for the light to pass through. When the exposure time is complete, they close again. Speeds with this sort of shutter usually range from 1 second to $1/500$ second.

Modern shutters are calibrated on the scale:

1, $1/2$, $1/4$, $1/8$, $1/15$, $1/30$, $1/60$, $1/125$, $1/250$, $1/500$, $1/1000$, $1/2000$ second. Usually, the setting dial is just marked with the division, thus setting 125 on the dial gives you $1/125$ second.

As with the aperture scale, each higher setting reduces the exposure to a half of the previous value.

Some older cameras used a slightly different scale, and many modern ones set the exposure time automatically to any point on the exposure scale.

The viewfinder is basically just a means of sighting the subject. However, in practice they vary tremendously from camera to camera.

To be really useful, a viewfinder should give you a large, clear image of exactly what is going to appear in your picture – some do and some don't. The only way to find out how good a particular viewfinder is, is to actually use it. Looking through it will tell you whether or not it gives a large, clear image but it won't tell you whether or not it is ac-curate. In actual fact, most viewfinders are on the cautious side and although in your picture you will usually get the scene you saw through the finder, you will nearly always get a little bit more, for good measure, at the edges.

Viewfinders fall into two categories: i) Those in which the subject is viewed directly from eye level (through an open frame, like a gun-sight, or through a little tunnel in the camera which has a lens at either end). ii) Those in which an image of the subject is reflected, by a mirror, on to a screen in the top of the camera. The first type is found in all modern simple cameras, in many more complex cameras, and in

press cameras. The second is found in all single and twin-lens reflex cameras. Most 35 mm and 120 size single-lens reflex cameras also have a prism incorporated in the camera which turns the image on the screen vertically through 90° so that it can be viewed from eye level. Using such a camera is almost like using one with a direct vision viewfinder.

Viewfinders found in cameras other than single-lens reflex types present one small problem. Because they are in a slightly different position to the lens, they see a slightly different view of the subject. This problem (it is called "parallax") only becomes serious at close distances and so, unless you plan to do a lot of close-up work it can normally be forgotten.

Each part of the camera is important in its own right and all must work together, reliably, to give you consistent results. However, there is one extremely important part of any camera which up to now we have ignored — the body. That simple, light-tight box which carries the film and holds those essential parts together. It is probably this, with its looks, its shape and its design, which attracted you initially; and it is this which decides whether the camera, as a unit, is going to be easy or difficult to handle. This, when it comes to the crunch, *is* the camera. Before you buy any camera, therefore, handle it, practise using it in the shop and really try to get the feel of it. Does the shutter release sit conveniently under a finger? Is the viewfinder easy to use? Is focusing quick and easy? Is it well-balanced and comfortable to hold? Compare it with others around about the same price range. Does it handle as well or not so well as they do? All these questions are important to you and only you can provide the answer. Spend a lot of time looking, reading, talking and testing the cameras you are interested in — just as you would if you were buying a new car — for the way that the camera handles will determine to a great extent the sort of pictures you can get with it. Any reasonably constructed camera that takes ordinary film is suitable for taking colour pictures. Only one or two instant picture cameras are confined to black-and-white photography. Let's take a look at the various types of camera available and try to weigh their advantages and disadvantages.

Although there are thousands of different cameras on the market, most of them slot fairly easily into a few specific groups. There are obviously different ways of categorizing cameras depending on the pur-

pose you have in mind, but for our purpose probably the best yardstick is film size. The film sizes we shall concentrate on here are 110, 126, 35 mm and 120. These are the sizes which are most readily available and which are likely to attract the attention of the would-be colour photographer.

110 Cameras

The camera which takes this size of film is a relative newcomer. It uses film in easy-to-load cartridges, and gives transparencies or colour negatives 13 × 17 mm in size.

Most 110 cameras are intended for basic snapshooting; they are simple, light and easy to use. Exposures are usually controlled by weather symbols. A few of the cameras in this category go to a fairly high level of precision with wide-aperture, high-quality lenses and electronic shutters.

At the risk of being labelled conservative in outlook, you may find it advisable to leave these cameras to those for whom they are best suited – the casual snapshooter who is more interested in taking record photographs than making pictures. For serious work, the extremely small film size is a definite disadvantage. The pictures, whether they are slides or prints, have to be enlarged a great deal to be worthwhile and unfortunately when you enlarge a picture you also enlarge its defects. A tiny scratch which might pass unnoticed on an enlargement from a larger size film may well be ruinous on a similar sized enlargement from a 110 negative. There are also limitations on the varieties of film available. If you already have one of these cameras, then, by all means use it and learn with it. If you really feel you must buy one, then do so and use it primarily as a photographic note-book, for this is a job it will do well. However, a 110 size camera is really not ideal for serious work.

126 Cameras

Although, chronologically, the reverse is true, cameras which take this size of film tend to be scaled-up version of those taking 110 size.

They are, in the main, simple and convenient to use, with essential controls being kept to a minimum. Like 110 cameras, they usually have weather symbols instead of shutter speeds and apertures, and, again like 110 cameras, the film comes in a light-proof cartridge which is dropped into the camera.

Film size, however, is larger (you get a negative or transparency measuring 26 × 26 mm) and this makes them more worthy of consideration as a "first" camera, one to feel your feet with. However the film may not be held too exactly, and some models may not give you critical sharpness for big enlargements. Provided you recognise the limitations of this type of camera, it is unlikely that you will ever have a picture which doesn't turn out. This can give a hefty boost to your ego and your enthusiasm.

If you are not sure whether making colour pictures is going to become a serious hobby or not, then it might be a good idea to begin with one of the medium-priced cameras in this range. Choose one which will let you take pictures in a variety of weather conditions and see how you get on. If you enjoy picture-making, you can always move to a more advanced camera, if not, then you have the ideal snapshot camera for your holidays.

35 mm Cameras

The 35 mm camera undoubtedly holds pride of place as the most popular camera amongst serious amateurs and even many professionals. The main reasons for this are its convenience − it is comparatively light and easy to carry, its speed in use and its versatility − many have interchangeable lenses and some take a vast range of accessories ranging from microscope adaptors to motorized film winders. Carefully used, 35mm cameras can produce excellent picture quality.

As with most things these days, you get very much what you pay for but (provided you know what you are doing) picture quality is almost certain to be higher than with a similarly priced 110 or 126 camera. However, cheap 35 mm cameras tend to be less flexible and less automated than the more expensive ones − you have to concentrate a little more on what you are doing. One reason for the improved quality

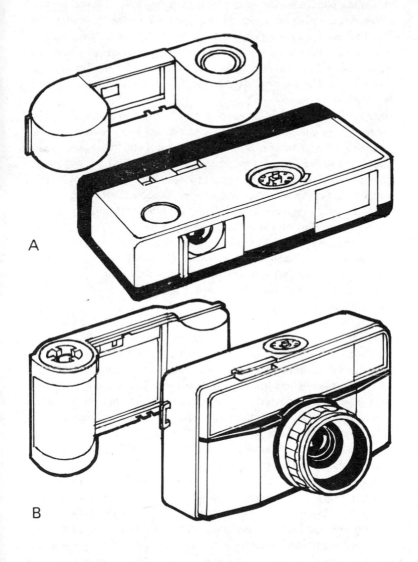

Two simple cameras with their film cartridges. A. Uses 110 cartridges
B. Uses 126 cartridges.

is that the picture area is larger (you get a negative or transparency measuring 24 × 36 mm) and therefore you don't have to enlarge it as much to reach easily viewable proportions. Also, the film alone is positioned by the engineered camera parts (the pressure plate and film guides) and this is held exactly in the right place. 35 mm cameras can be sub-divided into two main types: the single-lens reflex and the view-finder 35 mm camera.

The single-lens reflex (or SLR, to give it its common abbreviation) is generally very quick and easy to use and is extremely adaptable. The image from the taking lens is reflected by a mirror on to a ground glass screen. You may look down directly on to that screen; but most 35 mm SLR's are fitted with a pentaprism which gives normal eye-level viewing of the screen image. The major point in the favour of the SLR is that the image you see through the finder is the one which you will get on the film. This is a big advantage if you use a non-standard lens, such as a zoom or if you do close-up work, when with any other type of viewfinder parallax could present problems. You can also en-sure, when you are taking the picture, that your focusing is accurate – you can see whether the image is sharp or not. With an SLR there is no excuse for unsharp pictures.

Unfortunately, the one weakness of this camera derives directly from its strength. When you release the shutter, the mirror which reflects the image to the viewing screen, swings out of the way to allow the image to fall on the film. This means that at the crucial moment of taking the picture you lose the image in the finder. Most cameras have "quick return mirrors" so the period of blank screen lasts only an instant. Some older cameras do not, however, and you cannot see an image again until you have wound the film on.

Viewfinder cameras have a separate means of sighting the image. Although to a great extent overshadowed by the SLR, their potential should not be ignored. Like the SLR, the more advanced cameras of this type are fitted with high-quality, large-aperture lenses (sometimes interchangeable) and shutters giving exposure times ranging from, perhaps, several seconds to $1/1000$ second. They almost certainly have a rangefinder (which greatly simplifies focusing) and an exposure meter to assess accurately the exposure. They are usually smaller and lighter, and possibly less prone to mechanical failure than the SLR.

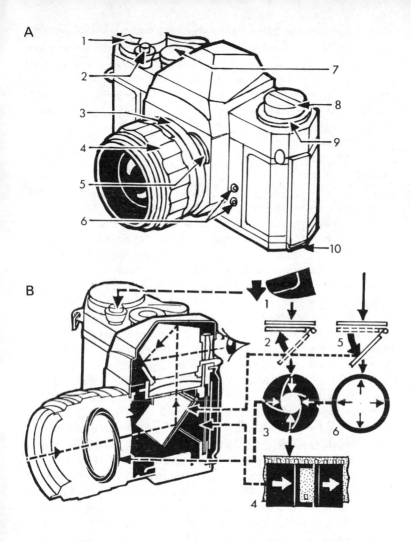

A typical SLR camera. (1) Film wind and counter (2) Shutter release
(3) Aperture Scale (4) Focusing mount (5) Lens auto-manual switch
(6) Flash contacts (7) Shutter speed setting knob (8) Rewind crank
(9) Film type reminder (10) Camera back latch. B. And how it operates:
(1) Release shutter (2) Mirror lifts (3) Aperture closes (4) Shutter opens
(5) Mirror returns (6) Aperture opens.

The simpler types of 35 mm cameras have a lot in common with 126 cameras. They are usually compact and light with simple controls and quite large-aperture lenses. They are comparatively inexpensive, both to buy and to run, and offer the advantages of the 35 mm format. All but the cheapest are likely to give better performance than a 126 camera. For the newcomer, they probably represent the best type of camera for starting colour work.

120 Cameras

If you are *really* looking for quality of a very high order in large blow-ups then a camera which takes 120 size film is almost essential. At one time no self-respecting amateur would consider an image size less than 2 $\frac{1}{4}$ × 2 $\frac{1}{4}$ inches worth considering, but now, the high-definition and quality possible from 35 mm cameras coupled with the lower working costs have left the 120 size very much the domain of the professional.

Many cameras which take 120 film will also accept size 220. This is simply a longer film offering you twice as many pictures per roll.

Modern 120 size cameras fall into three obvious categories: the single-lens reflex, the twin-lens reflex and the press-type camera.

There are two distinct types of single-lens reflex camera taking 120 film. One is based on the 35 mm SLR and is designed to be used at eye-level, a pentaprism passing the image from the viewing screen to an eyepiece. It is heavy, but looks and handles like its smaller counter-part. Models are available which give 10 pictures, each measuring 6 × 7 cm, or 12 pictures, each measuring 6 × 6 cm on 120 film. The other, more traditional type of 120 single-lens reflex camera is a completely different concept. This camera is designed to be used at waist level with the photographer looking down into the viewing screen. In this position it handles easily and rapidly. Most cameras of this design produce negatives measuring 6 × 6 cm, but there are some available giving 6 × 7 cm negatives. One camera, a cross between the two styles gives 6 × 4 $\frac{1}{2}$ pictures. it is smaller and lighter than most of the others, and, naturally gives more pictures on a roll.

Despite their weight, 120 film SLR's can be used extremely rapidly and a wide range of lenses and accessories is available to fit them.

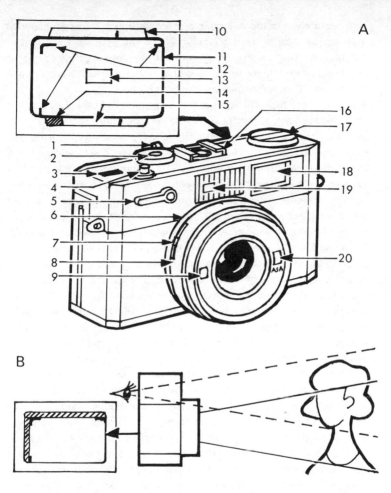

A. A typical viewfinder camera. (1) Film transport lever (2) Shutter speed dial (3) Exposure counter (4) Shutter release (5) Self timer (6) Aperture ring (7) Flash setting (8) Focusing ring (9) Meter window (10) Shutter speed indicator (11) Picture area (12) Parallax marks (13) Rangefinder area (14) Area of underexposure warning (15) Aperture indicator (16) Accessory shoe with Flash Contact (17) Rewind crank (18) Viewfinder (19) Rangefinder window (20) Film speed indicator. B. Parallax. Close-ups with viewfinder cameras can pose problems. To avoid cutting off part of the subject use the parallax markings in the viewfinder or tilt the camera up slightly.

Unfortunately, a camera, a couple of lenses and a set of accessories adds up to a large, rather heavy bill. To the serious, experienced amateur, wishing to produce pictures of the highest possible quality or perhaps do freelance work, these cameras represent a worthwhile investment. Otherwise they are best left alone.

If you want the high enlargement quality inherent in the 120 size but at moderate cost, then the twin-lens reflex camera is a good compromise. It is usually fitted with high-quality lenses and shutter and one model at least offers interchangeable lenses. The twin-lens reflex is just like two cameras in one; an SLR riding pick-a-back on a box camera, the box camera takes the picture and the SLR operates solely as the viewfinder. These cameras are designed primarily to be used at waist level, but most models incorporate a frame-type viewfinder in the hood of the viewing screen. This enables it to be used at eye-level. Most can also be fitted with prism type eye-level viewfinders.

Offering interchangeable lenses of high-quality and reasonably large aperture, a full range of shutter speeds and range finder focusing, the press-type of camera, as its name suggests, is designed primarily for press work. It is big and heavy, but extremely fast in operation, usually being held by means of a large handgrip at the side, which also incorporates the shutter release. As well as 120 or 220 roll film it may also accept glass plates and cut film giving negatives measuring either 6 × 7 or 6 × 9 cm. Capable of producing results of extremely high quality, it is definitely a professional rather than an amateur camera.

These then are the more common types of camera. All models in each category differ, some extensively, some only in detail. Obviously, it is only possible to give a broad outline here, summarizing the most basic differences. To find out more about individual cameras, the best thing you can do is to buy one of the popular photographic magazines. They all carry advertisements telling you about the various cameras currently available. Many of these magazines also conduct their own unbiased test reports, which can be extremely useful.

Don't forget the second-hand market, either. Provided you go to a reputable dealer you may well be able to purchase a first-class used camera for the same price you would expect to pay for a middle-of-the-range new model. Obviously you need to take a little more care choosing but most dealers will now offer you a reasonable guarantee, even on a second-hand camera.

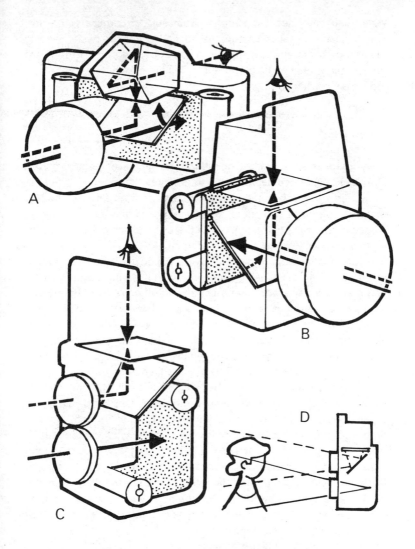

Three types of roll-film reflex camera. A. Single-lens reflex with pentaprism for eye-level viewing. B. Single-lens reflex with ground-glass screen for waist-level viewing. C. Twin-lens reflex for waist-level viewing. D. Don't forget, you can have parallax problems with a twin-lens reflex camera, too!

When you have decided roughly what sort of camera you want, whether new or second-hand, try to find a helpful dealer who is prepared to spend some time discussing your individual requirements. He can help you a lot – it's his business.

From then on, it's up to you.

Which Film?

Having chosen a camera, the next thing you need to consider is colour film. And this, of course, leads us to the question: Which is the best colour film? Well, to that question there can be no answer. Just as there can be no best camera, there can be no best film. However, what we can say categorically is that there are no *bad* colour films – or if there are, we have never heard of them.

Now, although all colour materials will give you good results provided you do your part in exposing them correctly, the results you get from one manufacturer's film will be somewhat different from the results you get from another manufacturer's film. For instance, if you take two pictures at the same time, one on Agfachrome and one on Kodachrome, the slides which you receive back from processing will probably be slightly different. The red in one will be stronger than the red in the other; one green will be more brilliant than the other. If you look at them alongside each other you will see this and you will see where they differ (always remember, if you are comparing colour pictures, it is only fair to compare them under the same lighting conditions and don't try to compare from memory – it just isn't possible).

Another thing which might seem a little odd but is true, is that even films from the same manufacturer can differ. Try taking one picture on Kodachrome-X and one on Ektachrome-X and see the difference. Yet both films are made by Kodak. The point is, each of these pictures when viewed on its own is completely acceptable. In 99 cases out of 100 the choice is purely personal.

So after all this, what is the answer?

Simply that you should choose one particular type of film, either on the recommendation of a friend or by sticking pins into a list, and use that film only. By doing this, you will get to know that film and what it can do, and you will get to know the sort of result you can expect even

before you press the shutter release. Then, and only then, should you experiment with different films if you would like to try something different.

Colour slides or colour prints?

Colour films are generally available in two sorts – colour negative films and colour reversal films.

A colour negative film is one which gives you a colour negative from which colour prints or enlargements can subsequently be made. All the colours and tones of the original scene are reversed. Dark tones become light in the negative and the colours are the complementaries of those of the original scene (red, for instance, becomes green, blue becomes yellow). However, when prints are made, the scene once again takes on its correct tones and hues.

Most colour negatives have an all-over orange appearance. This makes it rather difficult to see the colours and assess the quality. It is put there by the manufacturer in order to improve the quality of the final prints. Provided exposure and lighting were correct when you took the picture, all the colours are accurately reproduced when good prints are made.

Reversal films, which give you colour slides, are processed to give you a normal colour transparency. This is then returned to you by the processing station either ready for mounting or mounted in card or plastic mounts.

Working in either system has advantages and disadvantages. For instance, a colour negative is a "master". Once you have it you can keep it carefully and at any time in the future have further prints or enlargements made. You can even have good quality colour slides or black-and-white prints made from a negative. Although it is possible to produce colour prints and duplicates from a transparency, this will either be more expensive or will result in some deterioration in quality.

Colour negatives which are not completely satisfactory either in exposure or colour can often be improved somewhat during the enlarging process. This is not possible , of course, with a transparency which is itself the end result.

There is also the convenience factor to be considered. It is much easier to pass around a sheaf of prints for your friends to look at, than it is to set up a projector or pass around a viewer.

However, the advantages do not all rest with the colour negative. A well-exposed transparency offers far more brilliance, contrast and colour saturation than can ever be obtained in a print. When you see a really high-quality transparency projected you may find you can never really be happy with prints again.

Transparencies are cheaper than colour prints, too, when you compare the cost, shot for shot.

Finally, colour transparencies are much more suitable for reproduction in books or magazines, should the need ever arise.

Speed

The next thing you need to consider when choosing a film is its speed. Some films are more sensitive to light than others – they are "faster". We have to take the speed of our film into account when we are calculating exposure. However, more about that in chapter 3.

Colour negative films are all much the same speed. If you have a camera which takes 110 or 126 cartridges, too, speed is not going to worry you – the films which fit these cameras are all approximately the same speed. However, if you intend to make colour transparencies with any other camera, then choice of film is important.

The thing to remember is that the slower the film you use, the more contrast, brilliance and definition you are likely to get in your pictures (always assuming, of course, that you have done your part correctly). On the other hand, the faster the film you use, the greater the potential for taking good pictures in poor conditions. One has to be weighed against the other. You must decide what sort of pictures you intend to take before you actually purchase your film. If you are not going to need a high-speed film, then buy a slower one. It will repay you in terms of quality. The slowest films, however, produce transparencies which are rather too brilliant for some tastes.

The speed of most modern films is quoted on the packaging as an ASA/BS number or as a DIN number. The speed of a typical, general-purpose film would be ASA/BS 80, 20 DIN. One which was twice as

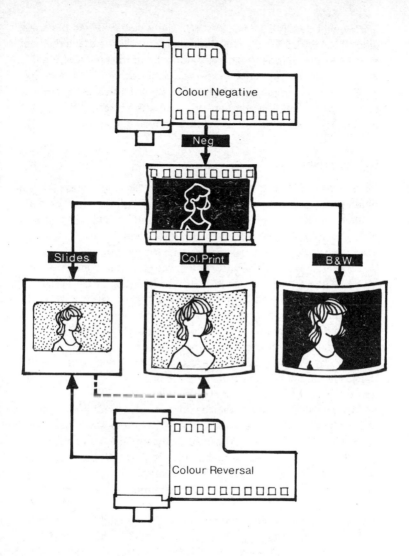

Colour films are made especially to produce prints or transparencies. Decide what the end result should be *before* you buy the film, this ensures you get the best results most economically. However, you *can* have colour prints made from transparencies and vice-versa.

fast would be ASA/BS 160, 23 DIN. One which was half the speed would be ASA/BS 40, 17 DIN. From this you will see that a doubling of the ASA/BS number indicates a doubling of the speed of the film, whereas with DIN numbers, the same is achieved simply by adding 3. It is a good idea to get used to thinking about film speed in terms of one speed system only, perhaps the ASA/BS figures. This way, you will find it quicker to compare relative films and speeds.

Colour Balance

More often than not, colour films are made in different types for use in different sorts of lighting. These sorts of lighting are: daylight, tungsten light (such as studio spotlights) and the illumination from high-powered photolamps (such as photofloods).

When we look around us, in any type of lighting, whether it be daylight, fluorescent light or tungsten, colours tend to look the same as they always look. If we sit in a room in the afternoon, gradually, as the day wears on, the light fades and it gets dark. So we switch the room light on and, apart from the fact that the illumination is coming from a different direction, everything appears as it was earlier on.

In actual fact, whereas earlier the room was illuminated by the bluish-white of day, when we switch the room light on, it becomes bathed in the yellowness of the tungsten light. We notice this for a brief instant as we switch the light on, but soon our eyes adapt to the yellowness, and we see everything as we expect it to be. Unfortunately, a colour film can't adapt like our eyes, and if we take a picture in a tungsten lit room with a film intended to be used in daylight, the resulting pictures will all have a strong yellow cast. Likewise, if we take outdoor scenes with film blanced for tungsten lighting, our pictures will have an unpleasant blue cast. Neither is to be recommended for conventional pictures.

If you need to use a film balanced for one type of lighting to take pictures in another sort of lighting, you must put a special filter over the lens. The correct one will be specified in the film instructions. This, of course, absorbs some of the light which would otherwise pass through the lens, and you need to give a longer exposure than would otherwise be necessary. Which is not a good idea, either. The moral is, if possible, try to buy the right film for the right lighting conditions.

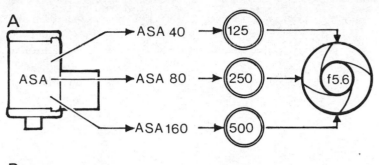

A

ASA → ASA 40 → 125 → f5.6
ASA → ASA 80 → 250 → f5.6
ASA → ASA 160 → 500 → f5.6

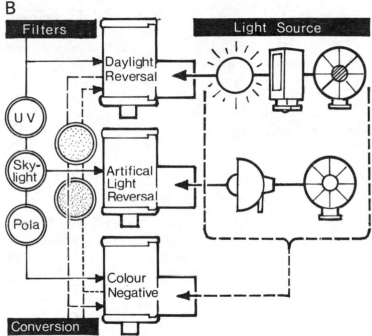

B

Filters

Light Source

U V

Sky-light

Pola

Daylight Reversal

Artifical Light Reversal

Colour Negative

Conversion

Films need the right amount of light (exposure) of the right colour. A. Doubling the ASA speed means that you can cut your exposure by half. B. For best results, expose a reversal film to the light source for which it is recommended. If you don't, you will need to fit a conversion filter over the lens resulting in a loss of film speed. You *can* use negative films in any light, but you get better negatives if you treat them like daylight type transparency films.

Getting the
Best from
Your Camera

Taking pictures in colour (or even in black and white) can be a very hit-or-miss affair with few of your pictures turning out reasonably well. On the other hand, by working carefully and methodically, it is possible to obtain an almost 100 per cent success rate. The type of camera you own, be it a battered box camera or an expensive, up to the minute, single-lens reflex, is not too important. What is important is how you handle it, and whether or not you know how to get the best from it.

Read the instructions

The most useful accessory you are ever likely to own comes free when you buy the camera – the instruction book. It's amazing how few photographers even bother to open it. Frequently, in the first flush of excitement, the instructions get pushed to one side and forgotten about. It's a shame really, for the manufacturer is likely to know the best way to operate a camera and is most qualified to advise you. They have a real interest in your pictures, for if you get good results, your friends may buy the same type of camera.

So, make sure that the first thing you do when you get your camera – certainly before you start operating it – is read the instructions. Find out how to handle it correctly and how to operate the controls. Pick up any little hints or tips that the manufacturer can give you. Then, when you are satisfied that you understand the camera, put the instruction book away in a safe place where you will be able to find it when you need it. It is a good idea to re-read it (perhaps every six months or so).

At a later reading, you often come across a detail which you had previously overlooked or even forgotten about.

What's it all for?

Some cameras seem to be chock full of gadgets with knobs, buttons and levers sprouting everywhere. Others seem to be so simple they leave you with nothing to do but press the button. Whatever the camera, the most important controls on it are there to enable you to

do two things: i) make properly exposed pictures (which are neither too light nor too dark); ii) make sharp pictures which are not blurred or fuzzy.

To a certain extent, the controls which enable you to do these two things are linked and you will sometimes find yourself altering the exposure controls in order to ensure that parts of the picture which you want sharp are rendered sharply. More about that, later, however. To begin with, let's look at the two requirements of correct exposure and sharp focus individually.

Exposure

To produce a picture which is neither too light nor too dark and in which all the colours and tones of the original scene are faithfully reproduced, you have to expose the film correctly. That is, you have to allow just the right quantity of light to pass through the lens for just the right length of time. Too much exposure and the print or transparency will look pale and washed out, with faded watery colours. The highlights and bright colours will contain no detail, the dark areas will be too light and there won't be a good black in the whole picture. Too little exposure, on the hand, will produce a transparency or print which is dark and gloomy looking with heavy shadow areas completely lacking in detail.

The exposure is determined by the time that the shutter is open (the shutter speed) and the intensity of light falling on the film. The intensity is determined by the brightness of the subject (i.e. amount of light reflected from it) and the lens aperture (f-stop). In most cases, you can't change the colour of your subject, or the amount of light reaching it.

Thus, the correct combination of shutter speed and aperture must be set to suit the subject and lighting. On a sophisticated camera, there are often many combinations which give the same exposure (see page 52), but you must still decide which series of combinations is correct. One point to remember is that your exposure calculations must be for the film speed (ASA or DIN number) you are using. If you have a simple cartridge-loading camera, however, you are confined to a single film speed (which simplifies matters).

How do you decide on the correct exposure for the film speed and conditions? It's no use relying on guess work, that will give you nothing but wrong exposures. There are three possible ways to find the right ones. They are: i) using symbols marked on the camera (if it has them); ii) using an exposure table (or a calculator); and iii) using an exposure meter.

Weather symbols are marks corresponding to lighting conditions, which are used on some cameras. Changing from one weather symbol to another changes either the lens aperture (allowing more or less light to pass through the lens) or the exposure time (allowing the light to pass through the lens for a longer or shorter period). Most cameras with weather symbols take only one speed of film, on others the symbols supplement more technical calibrations, and you may be able to choose your film speed. If you have a weather-symbol camera, the only problem is remembering to set the correct symbol to match the prevailing weather conditions. For instance, if you are on a beach and the weather is bright and sunny, then simply set the symbol which relates to sunny, seaside conditions. If the weather is dull and overcast, set the cloudy, dull symbol. Some cameras have only two weather symbols, usually one for bright sun and one for weak, hazy sun. If so, these are limitations which you have to get along with — there isn't a great deal of point in trying to take colour pictures in conditions other than these. For instance, if the skies are overcast and grey, you will be wasting film if you set the weak hazy sun symbol and hope for the best. Exposure is especially critical with transparency film. It must always be as nearly accurate as possible. You can sometimes get away with slight under- or over-exposure if you are using colour negative film.

If you would like to be more scientific about your picture-taking, you might be interested in knowing what exposures the symbols marked on your camera represent. In conventional photographic terms they are more or less:

Bright sun on light sand or snow	— $1/80$ sec $f22$
Bright sun (distinct shadow)	— $1/80$ sec $f16$
Weak hazy sun (soft shadows)	— $1/80$ sec $f11$
Cloudy bright (no shadows)	— $1/80$ sec $f8$
Cloudy dull or open shade	— $1/80$ sec $f5.6$

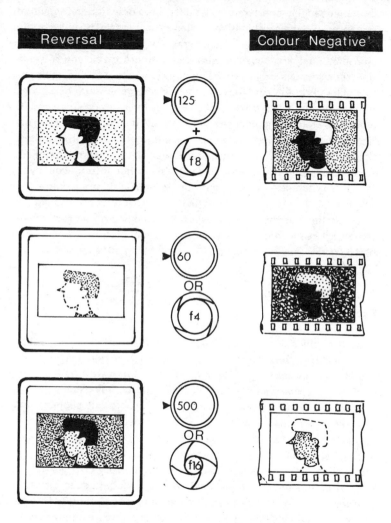

The immediate obvious effect of exposure is on the density of the colour transparencies or colour negatives. Changing either the aperture or the shutter speed from the correct settings, top, produces over exposure, middle, or under exposure, bottom.

Of course, depending on the individual camera, the combination of shutter speed and aperture may be different. For instance, instead of $\frac{1}{80}$ sec. at f5.6 the combination is often $\frac{1}{40}$ sec at f8. The point is, the exposure is the same but the figures are different. Knowing the exposures that are possible with your camera gives you a much greater degree of flexibility in the pictures you take. You see, the symbols marked on the camera cover only a very general range of conditions – ones which are likely to be faced by the average snapshotter. When you start taking pictures which are even slightly out of the ordinary, you will find that you need more information than the symbols alone can give you. Supposing, to take a very simple example, you are on the beach and the weather is overcast – what setting would you use? It isn't too easy to work out from symbols but, if you know the actual exposures you are able to give – no trouble at all. You simply work out the right one using an exposure guide or a meter and, if your camera is capable of giving it, you can take your picture.

And this brings us to the next method of working out exposures.

Exposure tables

Exposure tables are often included in the instruction sheet packed with the film you buy, or they can be bought for a few pence. Those with the film simply list suitable exposures for that film with normal-type subjects in typical weather conditions. Those you buy usually go a lot further and let you work out exposures for different subjects and weather conditions using films of different speeds.

Tables like this are easy to use and remarkably accurate for most average subjects. However, they tend to become less reliable as the pictures you take become more sophisticated. Very complex tables and calculators are available, which take into account such things as position of the sun, time of year, latitude and a host of other factors, but although they can suggest very accurate exposures, they tend to be a little complicated and rather slow to use. Rather than go to these lengths (and still occasionally be faced with conditions and subjects which are not catered for) it is usually a better idea to invest in an exposure meter.

Exposure meters

The only difference (but an important one) between an exposure meter and a calculator is that with a meter you actually *measure* the light being used to take the photograph. You then set the reading you have obtained against the film speed and read off the exposure. Exposure meters are very easy to use but by no means infallible.

There are two types of exposure meter in common use at present: reflected light and incident light. Each has its own particular advantages and disadvantages.

Reflected-light meters measure the total amount of light coming from everything which lies within their field of view. This is convenient, because you can use such a meter from the same position as the camera, but it can lead to problems. You really need to measure only the light reflected from the subject (because this is what you want correctly exposed). However your meter will also take into account the background, the foreground and everything that lies to the sides of your subject. The result can be a wrong reading.

For instance, suppose you are taking a picture of a girl, who is standing on a rock about fifteen feet away from you; the background is hazy blue sky in which there are fluffy white clouds. Simply pointing the meter at her from the camera position is certain to give a misleading reading. The trouble is, the brightness of the clouds and the sky will influence the meter far more than will the subject, so the exposure it suggests will be hopelessly short, and following it will give you a badly under-exposed picture.

In cases such as this – in fact, in most cases – it is necessary to take the meter close to the most important part of the picture. That is, obviously, the part which must be correctly exposed. Therefore you have to go much nearer to the girl and take a reading from within a few inches of her face (make sure you don't cast a shadow with your hand, though, or this will give a low reading). By doing this, you will be measuring *only* the light which is reflected from the girl's face – and, if her skin tones are recorded well, everything else will follow.

Pictures of scenery can also present problems. Here again, there tends to be rather a lot of sky included and the way round this is to tilt the meter downwards slightly. If you do this, the meter will "see" less of the sky than it otherwise would, and give you a reading which is more

likely to be accurate for the whole picture.

Reflected-light meters are designed for reading from the whole sub-ject, or from mid-tones. Take a reading from a mid-tone (pale grey or flesh-tones for example) and it will be recorded as a mid-tone in the picture. Take a reading from an area of shadow, however, and guess what? It will record as a mid-tone. It will be over-exposed and too light. On the other hand, if you take a reading from a light-tone, the result will be under-exposure. The highlight area will record too dark – as a mid-tone in fact.

Some cameras have reflected-light meters built into them. The same problems arise, and can be tackled in precisely the same way. However, in others, the meter is coupled directly to the shutter and aperture mechanisms. Exposure setting is out of the photographer's hands with this sort of fully automatic camera. The exposure is assessed as you press the shutter release and you may have no means of altering it. Sometimes the automatic mechanism can be over-ridden and you can make corrections as you wish. Sometimes, the camera is fitted with an exposure compensation mechanism or a full manual over-ride. In the absence of any other system, you may be able to alter the film speed setting to change the exposure. Setting a higher film speed will cause the camera to give *less* exposure; setting a lower speed will cause the film to give *more* exposure. Changing the ASA setting by a factor of 2 (adding or subtracting 3 from the DIN speed) doubles or halves the exposure. Your camera instruction book may give details.

To save the photographer having to go in close to the subject to take a reading, some built-in meters in single-lens reflex cameras work in a different way. They allow you to take what is called a "spot" reading. What happens is you select a very small area (or spot) of the subject and take your reading from that. You must make sure you take the reading from an important area, or a suitably representative mid-tone, though. For instance, if your picture has people in it, take a reading from a face or a hand (but make sure that it is not shaded from the overall lighting). This will ensure that the flesh tones are well recorded and, as we said before, if they look right it is fairly certain that everything else will be recorded reasonably well. You can buy a separate spot meter, but this needs at least as careful use, and is only really needed for specialist professional work.

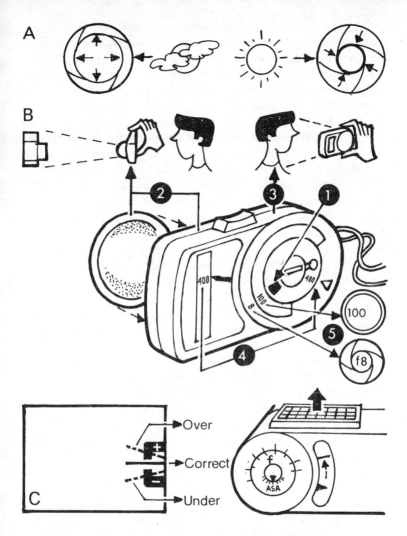

A. Setting the weather symbol on a simple camera ensures that the exposure is set correctly. B. Using separate exposure meter (1) Set ASA speed (2) take an incident light reading (using the incident light baffle) or (3) take a reflected light reading. Use switch to hold meter reading (4) transfer reading to calculator dial (5) Read off shutter speed against aperture. C. Built-in meters may have meter needle in the viewfinder or calculators on top.

Incident light meters provide you with an alternative to measuring the light coming from your subject, you can measure the light falling on it. You can often take incident light readings if you fit a special diffuser to a reflected light meter. Alternatively, you can approximate an incident light reading by measuring the light reflected from a suitable (18 per cent reflectance) grey card. Following an incident light meter (or a grey card) reading gives you a picture which will be faithful to the original subject tones. However, if your subject is particularly light or dark, you may want to alter the exposure to compensate somewhat. More exposure will lighten the subject, less exposure will darken it.

With an incident light meter you *have* to stand by the subject and then, oddly enough, point it at the camera. The advantage is that very light or very dark areas of the subject or the background will not influence the meter to give an incorrect reading.

Giving $\frac{1}{2}$- to 1-stop more will produce a more correctly exposed picture where there are lots of dark areas, while $\frac{1}{2}$- to 1-stop less will help if the tones are mainly bright. The instructions which come with the meter should give you full details.

We have gone into some detail about the types of light meter most popular with amateur photographers. This is not to say that there are not other sorts — there are. The important thing to remember, though, is that it is not the sort of meter or calculator you use which counts, it is *how* you use it. Follow the instructions you get with it, and use it carefully with consideration for the important parts of the picture. It's just as easy to get an incorrect exposure with a meter as it is a correct one, but, with a little bit of care it won't happen.

The next step

When you come to read the exposure from your meter or calculator, you will notice that there are quite a few combinations of aperture and shutter speed which you can use: $\frac{1}{500}$ at $f4$, $\frac{1}{250}$ at $f5.6$, $\frac{1}{125}$ at $f8$, $\frac{1}{60}$ at $f11$ and $\frac{1}{30}$ at $f16$ sound very different but, in fact, they all constitute precisely the same exposure (give or take the odd $\frac{1}{5000}$ second). The next set of figures: $\frac{1}{1000}$ at $f4$, $\frac{1}{500}$ at $f5.6$, $\frac{1}{125}$ at $f8$, $\frac{1}{60}$ at $f11$, etc., are said to give one *stop* less exposure. Thus each step

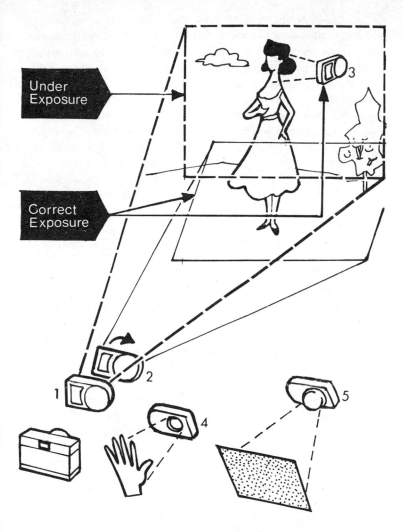

Under Exposure

Correct Exposure

Using an exposure meter to take a reflected light reading from a subject containing large areas of light or dark calls for a little thought. (1) holding the meter level results in underexposure due to the large area of sky affecting the meter (2) tilting it avoids the sky. (3) Readings close-up to the subject, (4) from a substitute, such as a hand or (5) a grey card, also give a more reliable figure.

(shutter speed *or* aperture) changes the exposure by one stop. The contents of the parcel are the same; it's just the packaging which is different. So, which one is the right one? Is there, in fact, a *right* exposure setting or will any setting from the list suffice?

The first factor which governs your choice of setting is, of course, your camera. If you only have a limited range of shutter speeds or apertures, then obviously you have to think within that range. However, there is another point you have to take into account, and that is picture sharpness.

Focusing the camera lens

If you have a fairly simple camera, the chances are it will not have a focusing mechanism. It will have a fixed focus and with it you will be able to take pictures which show everything sharply from about 4 feet away from the camera to infinity (infinity in photography is taken to be just about as far away as you can see: it is written ∞).

With other cameras, you have to move the lens slightly further from the film to set it to focus close-by objects. You do this by moving the focus control — usually a ring round the lens.

Some quite simple cameras have a series of symbols marked around the outside of the lens barrel. You set a pointer to a suitable symbol, and your lens is correctly focused. The instruction book will tell you exactly what the symbols mean for your camera but generally they refer to close-ups — usually about 4 feet to 10 feet, middle distance shots — about 10 feet to 20 feet and long shots — more than 20 feet or so. To ensure that the important parts of your picture are sharp, you decide what your particular picture is — whether it is a close-up, a middle-distance shot or a landscape — and then set the appropriate symbol.

Instead of symbols, you may have a distance scale (in feet or metres) engraved around the lens barrel or marked somewhere near the focusing mechanism. Again, it is necessary to estimate, or measure, how far away from the camera the subject is, and then set this distance on the focusing scale.

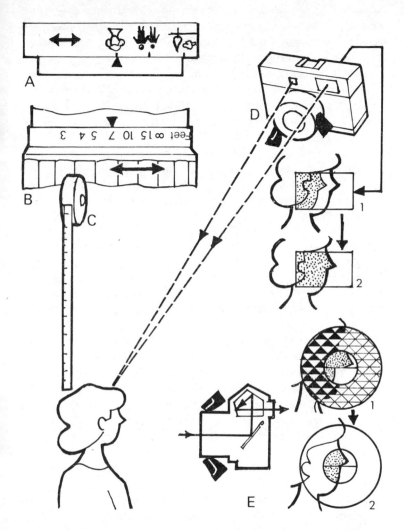

With all but the simplest cameras, you need to focus correctly. A. Focusing symbols are simple. B. You can set the distance on the focusing scale. C. Using a coincident image rangefinder (1) Out of focus (2) In focus. D. SLR cameras usually have a rangefinder, either microprism or split image (or a combination) for focusing (1) out of focus, (2) in focus.

Focusing is most critical at very close distances and becomes less important the farther away the subject is from the camera. If your subject is 12 inches away, then accuracy to within the half-inch is essential. However, from about 20 feet onwards, a more casual approach is possible. It's a good idea to try to be as accurate as possible about focusing, though, whether you are working close to your subject or not. Nothing is more irritating or disappointing than having a picture which is good in all other respects spoiled because the subject is blurred.

There are several ways of ensuring that your pictures are going to be sharp in the right places. The least expensive way is by learning to estimate distances fairly well. It isn't difficult to do this. One way is by imagining how many men, six feet tall, lying flat on their backs would fit between you and the important point in your photograph. For closer distances, a tape measure may be used.

A much more convenient method of measuring distances, though, is to use a range finder. This is an inexpensive accessory with usefulness out of all proportion to its size. Rangefinders have an eyepiece through which you view the subject you are photographing. Depending on the type of rangefinder, the subject is either seen as two separate images which have to be fused into one, or split into two halves which have to be joined together. Fusing or joining the images is achieved by turning a small calibrated wheel on the rangefinder. When this is done the distance of the subject from the rangefinder is read from the calibrations. Some cameras have a built-in rangefinder and this may be either coupled (in which case operating the rangefinder automatically focuses the lens) or uncoupled (when the distance indicated by the rangefinder has to be transferred to the lens).

Reflex cameras (both twin- and single-lens) are focused by watching a reflection of the image on a viewing screen. As you move the lens backwards and forwards from the film you can see the point at which the image comes into sharp focus. Most single-lens reflex cameras also incorporate a rangefinder. This consists of a small circular spot in the centre of the viewing screen. It may be the microprism type: when it is in sharp focus, the image is seen clearly and distinctly in this area. When it is not in sharp focus, the image breaks up into a confused pattern of criss-crossed images. Alternatively, some cameras are

fitted with split-image prism rangefinders, or a combination of split-image microprism rangefinders.

So, although we now know about focusing the camera, what has all this got to do with setting the exposure?

Depth of field

If, when we took a photograph, only objects at exactly the distance focused on were sharp, it would be very difficult to take the variety of pictures we would wish. Fine for portraits, perhaps, although long noses might cause problems, but what about landscapes, where we want everything from a few feet away from the camera to infinity to be sharp. Fortunately, in practice things from some way in front of the focus point and to some way behind it always come out reasonably sharp. The distance from the nearest sharp part to the furthest is called the depth of field. It can vary from as little as a few millimetres to practically the whole distance from camera to horizon.

Altering the depth-of-field is one way of controlling your pictures. You can use a minimum of depth of field to isolate the sharply rendered subject against a soft out of focus background (and, possibly, foreground). You might do this with a close-up of a flower or a full-length portrait of a person. On the other hand, you can use the maximum depth of field to get as much of your subject as possible sharp. This might give the best results in a picture of a busy town street.

The extent of the depth of field depends on several factors but there are two over which we have immediate control. They are:

a) the distance of the subject from the camera, and

b) the lens aperture.

Depth of field increases as the point of focus moves away from the camera. As the zone of sharp focus also extends *beyond* the point focused on, there comes a time when, although the lens is not focused on infinity, the depth of field will stretch to infinity. Therefore, focusing on a point nearer to infinity than this will result in a *decrease* rather than an *increase* in depth of field. Depth of field also increases as we reduce the aperture of the lens. With a aperture of $f11$, for instance, the same lens gives a greater depth of field at any given dis-

tance than, say, *f*8. To achieve the greatest depth of field you need to use a fairly small aperture and focus on a point in the middle distance. This, in fact, is how non-adjustable cameras are set up, the lens pre-focused on a distance of about 15 feet and having an aperture of about *f*16. This ensures that everything from about 4 feet away from the camera to infinity is more-or-less sharp in the picture.

A third factor which affects depth of field is one over which we have rather less control. It is the focal length of the camera lens – the shorter the focal length the greater the depth of field at any particular *f* number and distance setting. The focal length of any camera lens is the distance from the film plane to a point called the nodal point (which is located near the centre of the lens) when the lens is focused on infinity. You will probably find the focal length of your lens marked on the front of the lens near the manufacturers name – it is usually expressed something like this – *f*:45.

For any one size of camera the focal length of the standard lens fitted will be about the same as for any other camera of that size. Thus, the standard lens for any 35 mm camera will be about 40 – 55 mm; for any 6 × 6 camera, it will be about 75 – 90 mm. This, of course, means that a 35 mm camera with a standard lens offers greater depth of field than a 120 camera fitted with *its* standard lens. For the same reason, wide-angle lenses (which are always of shorter focal length than standard lenses) give greater depth of field than the standard lens, whereas long focus (telephoto) lenses give less.

To avoid guesswork, many cameras incorporate a depth of field scale between the focusing scale and the aperture ring, and this shows you exactly how much depth of field you will get and where it will lie for any combination of distance and aperture. If you haven't got such a scale on your camera, most photographic dealers sell calculators which give the depth-of-field information you will need for most popular focal lengths of lens.

Movement in the picture

Movement in the picture can come from two sources: from you, if you move the camera as you squeeze the shutter release; and from the

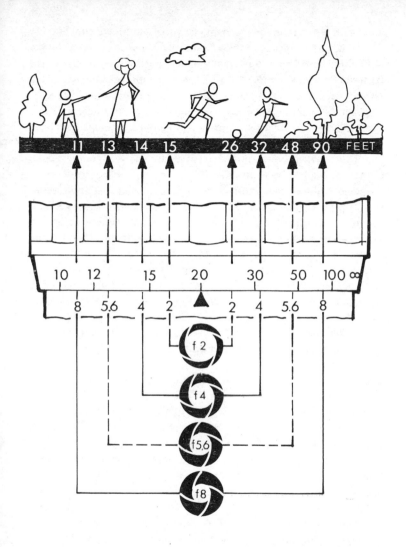

The effect of aperture on depth of field. Here, the camera lens is focused on a subject 20 feet away. At *f*2 only subjects within the range 15–26 feet from the camera will be in sharp focus. At *f*8, however, subjects from 11 feet to 90 feet from the camera will be reproduced reasonably sharply. For all practical purposes, the more you stop down the more you increase depth of field.

subject, if it happens to be moving as you take the picture.

The first sort of movement can ruin any picture (unless it is done deliberately) and should normally be avoided. Although it imparts a blurred effect to all parts of the picture, it is not the same sort of unsharpness you get in an out-of-focus picture. You can usually distinguish between the two by looking closely at the negative or transparency. Accidental camera movement usually imparts a double-image effect to everything in the photograph. An out-of focus picture often has some points in it which are sharp while the outlines of the rest are generally softened.

To avoid camera movement when you are taking the picture you should practice holding the camera steady. Always keep your feet slightly apart, stand comfortably and breath in slowly before you *squeeze* the shutter release. Never *press* the trigger hard downwards, this will almost certainly produce an unsharp picture. Unless you have a very steady hand indeed, avoid using shutter speeds slower than $\frac{1}{60}$ second. If you have to use slower speeds, try to find something solid, such as a wall or a table to rest the camera on — even holding the camera *against* a wall will do the trick but it's a bit awkward viewfinding when you do this. If you have a very unsteady hand or plan to take pictures using slow shutter speeds, it may be worth investing in a good tripod.

The second sort of movement — subject movement — is the natural movement of people and things in your picture. Taking pictures of children, for instance, will almost certainly produce a small percentage of pictures which are spoiled, purely and simply because the kids moved suddenly just as you took the picture. Obviously, if you want natural pictures, you don't order the children to stop moving (that's probably impossible, anyway), so the answer is to use a fast shutter speed and freeze the action.

For most average subjects, including people who are expecting to be photographed, a shutter speed of $\frac{1}{60}$ to $\frac{1}{100}$ second should suffice. However, where there is definite movement, such as people walking fairly quickly across the field of view, you will need to increase your shutter speed accordingly. It is difficult to categorize here every sort of movement and decide what shutter speed is necessary to stop it, but some suggestions are offered on page 131. Remember too, that not all movement is obvious. Think of the shutter speed necessary to

produce a sharp picture of a runner moving across your picture. Do you immediately think, too, of the movement of his legs and arms — which are probably moving a lot faster than the rest of his body?

Which exposure setting?

Having worked out the exposure required to produce a well-exposed picture, the poor photographer is still left with a decision to make. Which combination of shutter speed and aperture should he use? The two conflicting requirements which have to be reconciled are the need to use a sufficiently large or small aperture to give the required depth of field and the need to keep the exposure time short enough to freeze any movement.

More often than not, there will be no conflict of requirements. A picture which demands great depth of field does not usually have in it objects which are moving at high speeds. If a choice does have to be made, however, then the less important has to give way to the more important, and only you can decide this. If you have the opportunity, take several shots, trying different combinations of shutter speed and aperture — this way, at least, you stand a good chance of obtaining a reasonable picture.

It is a good idea to always have your camera set at "snapshot" settings so that if a picture suddenly comes up and you don't have time to make adjustments you can fire away with the chance of getting an acceptable picture. Using a film rated at 64 ASA/BS the settings you might use would be 1/60 second at *f*11 or *f*16 and the focusing set to 15 — 20 feet. Obviously, sudden unrepeatable situations don't arise very often, but it's nice to know you can handle them when they do. For picture-taking in the normal way you then go back to the more scientific methods of working out exposures and focusing.

Flash

Most cameras, nowadays, are sychronized for flash. All you have to do is pop a flashgun on top of your camera, connect a lead between flash and camera and suddenly you are independent. You can go

where you will when you will with no worries about whether the light is strong enough to take pictures by — you carry your own little bit of bottled sunshine with you. With simple cameras it can be even easier. You just plug a little device called a magicube on to the top of the camera and you can fire off four flash shots without connecting a wire or changing a bulb.

There are four popular types of flash equipment: magicubes, flashcubes, bulb flashguns and electronic flashguns. Your camera will probably be equipped to take one or, perhaps, two of them. Check in the instruction book which type you want.

Magicubes are the simplest flash sources. They consist of a little cube divided into four compartments each containing a flashbulb and its own reflector. Magicubes simply push into a socket on the top of the camera. They are fired mechanically by a trigger operated when the shutter is released, so they don't depend on batteries or any other accessories. This means they are extremely reliable. As each bulb is fired, the cube is rotated so that the next bulb faces forwards ready for another picture. Magicube cameras usually have suitable flash distances marked against their aperture setting scales. If they don't, check in the instruction book, and don't go outside the limits given. If in doubt, a single setting camera (or a camera set for bright sun) should give reasonable results with subjects between about 4 and 9 feet ($1\frac{1}{4}$ and 3 metres) from the lens.

One drawback to using magicubes is that they are normally positioned very close to the camera lens. This can give rise to two problems. The first is that because the illumination of the subject is very flat and shadowless, the shape of the subject can be lost. You can demonstrate this with a torch and a friend to help you. Turn out the room lights at night so that the room is dark; then switch on the torch. Hold it close to your eye and direct it on to your friend's face, see how the shadows cast by features such as the nose, eyebrows and lips are very tiny — almost invisible. When you take a picture, you need some modelling to portray the shape of your subject. The lack of modelling from direct lighting tends to flatten it just like it flattens the face. Now move the torch up about a foot and six inches to the side — notice the improvement?

The other problem occurs mainly when you are taking fairly close-up pictures of people and is known as "red-eye". The effect is pretty ob-

vious from the name of the complaint – the pupils of a person's eyes come out bright red in the photograph. This rather vampirish complaint is caused by the flash being reflected back from the retina of the eye. Both problems can be cured by moving the flash further away from the camera lens. Magicube extenders are made to do just this. If you haven't got one of these accessories, then red-eye can be alleviated somewhat if the picture is taken in a brightly-lit room. This causes the iris of the eye to close down so cutting down the size of the red reflection.

Flashcubes are identical to magicubes in all respects but one: they are fired, not mechanically, but by an electric current. To supply this power, you need batteries either in the camera (if it is an integral flash system) or in the flash-cube holder.

Bulb flashguns for amateur use are small, portable units powered by batteries. They have reflectors to ensure that the light from a bulb is thrown forward, evenly, into the picture area. A flashgun is connected to the shutter either with a co-axial cable which plugs into a socket on the camera; or through contacts in the base of the unit and in the camera's accessory shoe. Flashbulbs vary in size and power, colour and synchronization characteristics. The most commonly used bulbs are number AG1B – tiny, blue bulbs which give a powerful flash of light, lasting, perhaps, $1/30$ second. Although this may seem brief, the light output is sufficient to allow you to photograph subjects as far as 15 feet from the camera – or even further if you are using a really fast film. Because they are blue, the light they give out is similar to daylight in colour. So you use daylight type films with them. The main disadvantage of flashbulbs is that they can only be used once – after the flash, they are burned out and useless. This makes them, in company with flashcubes and magicubes, a rather expensive form of lighting.

Electronic flash is produced from a special gasfilled tube. Compared with the other types of unit already mentioned, electronic flashguns call for a fairly high initial investment; but after that, you are coasting all the way. The flashtube (which is the equivalent of the bulb) is good for many thousands of flashes. Some electronic flashguns are powered by batteries which have to be replaced, others use a rechargeable battery, and some can work directly from the mains supply. This makes them particularly economical to run. The problem

with special rechargeable batteries is that once you have run out of power, the flash-gun cannot be used until it has been recharged from the mains. This usually takes several hours. Perhaps the best combination is a mains gun which can also take readily available batteries. Like blue-coated bulb flash, the colour of the light from an electronic flashgun is similar to daylight.

The duration of the flash from an average electronic unit can be as brief as $1/1000$ second. This offers an advantage in that you can "stop" extremely fast action, even though you may not have a very fast shutter speed.

Flash exposure

To work out the exposure, flash units are given a *guide number* by the manufacturer. These guide numbers take into account the amount of light and the film speed. To use a guide number you simply divide into it the distance of the subject from the flash unit and the result is the lens aperture in *f*-numbers. Alternatively, you can divide the guide number by the lens aperture, and the result is the distance the subject needs to be from the flashgun. (The guide number can be given for the distance in metres or in feet — or both; make sure you measure the distance in the correct units). For example, with a guide number of 80 feet and a subject 10 feet away, the lens aperture you need to use will be $80/10$ that is *f*8. Alternatively, with a guide number of 16 (metres) and a lens aperture of *f*8 the distance from subject to flashgun should be 2 metres. When you are working out flash exposures, remember that the figures you arrive at from the guide number will, as the name suggests, only be a guide. The surroundings you are in will affect the exposure markedly. A brighly painted room which is rather on the small side will reflect a great deal of light. You may, therefore, need to close down your lens aperture $1/2$ − 1 whole stop to compensate. On the other hand, if you are in a large dining hall with dark oak panelling, you may have to open one stop. Guide numbers apply to average conditions, only. If you are in any doubt at all, it always pays to make one or two extra shots, opening up or closing down a little according to the situation.

A. Flashcubes and magicubes plug into a socket on the top of the camera. B. Electronic flashguns may have a stud in the base which makes contact with the 'hot shoe' in the camera, a co-axial cable which plugs into the 'X' socket in the camera or, perhaps both. C. Bulb flashguns can usually be plugged into either the 'M' or the 'X' socket, but not for all shutter speeds or bulb types. If your camera has a focal plane shutter, check the instructions.

Flash synchronization

By now, you will have begun to wonder what happened to shutter speeds. Well, we are not forgetting them; with flash, they don't have quite their normal uses. The speeds you are able to use depend on the way the shutter works, the type of synchronization your camera uses and on the type of flash equipment you have. There are three methods of synchronization; they are M, F and X. Without going too deeply into the hows and whys of synchronization here, the points you need to know are these:

Focal plane shutters expose the image sequentially: one blind moves away to let the light reach the film, and a second blind follows it to stop the exposure. At slow speeds (often $1/60$ second or longer with horizontal shutters and $1/125$ or larger with vertical ones) the delay between the two blinds leaves the film totally exposed for part of the time. With faster speeds, only part of the film is exposed at any one instant. At high speeds, you must use a flash source which gives a constant light for the whole time that the shutter is operating. Special focal plane (FP) bulbs supply such a light, but they are expensive and hard to get. Ordinary small bulbs can be used, but the lighting may not be even across the whole picture. Either type of bulb is fired just before the shutter begins to open, so that it has time to build up to its full brilliance for making the picture. F- or FP-synchronization is designed to give a suitable delay for the build-up time of FP bulbs, and M-synchronization for the build-up time of other bulbs, In practice, the actual time varies from camera to camera, and from model to model; and you may get acceptable results with whatever bulb synchronization your camera has, and whatever bulbs are available. It can, however, be risky, and for important shots you are safer to use X-synchronization at slow speeds.

X-synchronization fires the flash just as the first blind reaches the end of its travel. With bulbs, you need to wait for the light to build up before the second blind starts to move. Otherwise, the picture is unevenly lit. Generally, you can use any sort of bulb at speeds up to $1/15$ or $1/30$ second.

Electronic flash produces all its light virtually the instant the contacts close. Thus it must be used on X-synchronization otherwise, it would

A. Always use X synchronization (sometimes ⚡) for electronic flash, M synchronization for flashbulbs (or X at speeds slower than 1/60 sec). B. Test synchronization by looking through camera and releasing shutter. To avoid dazzle, point flash away from camera lens. C. Prevent colour casts by keeping subject away from brightly-coloured areas or lamps for which the film is not balanced.

fire before the shutter starts to move. With focal plane shutters, electronic flash can be used at any speed at which the film is totally exposed for any part of the shutter movement. This is usually speeds of $\frac{1}{60}$ second with a horizontally moving shutter and $\frac{1}{125}$ second with a vertical shutter. It can be used also at any slower speeds. At faster speeds you will cut off part of the picture.

Diaphragm shutters are fitted to most cameras with fixed (non-interchangeable) lenses. As they expose the whole film at one go, flash synchronization is much simpler. You use M-synchronization for ordinary bulbs (don't use FP type bulbs at all), at any speed; but speeds shorter than $\frac{1}{30}$ second give reduced guide numbers. For electronic flash, use X-synchronization at any speed. As most units give flashes shorter than $\frac{1}{500}$ second, the guide number remains the same whatever speed you use.

So, you must use the right combination of shutter speed and flash unit for successful pictures. The method which applies to your camera may be marked near the flash contacts. Otherwise your instruction book should tell you. If you haven't got one, you will have to use trial and error methods to see what works. Without a film in the camera, connect up an *electronic* flash unit. Choose a suitable shutter speed (say $\frac{1}{30}$ th). Open the camera back, look toward the lens and fire the shutter. If you saw the flash *through* the lens, you have X-synchronization. If you don't see the flash, you have flash-bulb synchronization, (either M or F) and cannot use electronic flash. Most cameras, however, with only one sort of synchronization are X-synchronized.

Because it is so short-lived, the flash from an electronic unit is ideal for stopping fast action. Even if the shutter speed you use is as long as $\frac{1}{60}$ second, it is the flash of light which actually makes the exposure and it is that which stops the action. Have fun stopping a ping-pong ball in mid air, or the kids using the bed as a trampoline.

Problems

One of the problems which can arise if you use flashcubes, flashbulbs or electronic flash is flash failure. It always happens just as you take the crucial shot – the *big* one. Ninety-nine per cent of the time it is

avoidable, and ninety per cent of the time it is $^1/125e$ to battery or contact trouble. Most flashguns have fairly simple electrical circuits and it only takes a little bit of corrosion on the battery terminals or the contacts of the gun to prevent it firing. Take care of your flash unit; never store it with the batteries in position; take them out and store them separately in a warm, dry place; they could otherwise leak and ruin the unit. Before replacing the batteries, give their ends a rub on a dry, rough cloth to clean them of any grease or corrosion. Do the same with the contacts inside the flashgun, use the eraser on the end of a pencil to get at the ones deep down inside the case. Also clean the contacts of the hot shoe (the one at the base of the flashgun and on the accessory shoe of the camera) if you have one. Always use the correct batteries as specified by the manufacturer and don't try to make do with cheaper alternatives which are "just as good, sir". They will almost certainly let you down just when you need them most. Generally, manganese-alkaline and mercury batteries are better than zinc-carbon. They last longer and are less prone to leakage. Make sure too, you position them correctly in the gun. If in doubt, check the instructions. The one other possible cause of flash failure is the connecting lead between camera and flash. If it shows signs of wear, or slackness, then have it checked by a dealer.

With flash, it never pays to take chances.

Now you know how flash works. On page 155 we discuss the ways you can use it.

A few well-chosen accessories

If you read through some of the advertisements for photographic equipment, you will be amazed just how many accessories you can't afford to be without. Unfortunately, when you look at the prices, you realize you can't afford to be with them, either.

In many cases, this is not a bad thing. It is always better to start with a basic camera, find out what you can do with it and then, slowly, as you need them, buy the accessories which you know are going to help you make better pictures. This not only saves you money, it teaches you to get the best from your camera. There are, however, a few items – not exotic pieces of equipment at fancy prices – but real tools which

could almost be classed as standard issue. They are worth considering, before anything else, as worthwhile additions to your equipment. Have a look at the list and then make up your own mind.

Exposure meter

This is one item you can't really do without if you intend to produce high-quality colour pictures — you just have to get the exposure right or you don't have a decent picture. We have discussed the various types of exposure meter and calculator earlier on in this chapter, so if you don't have one built into your camera, find one which suits your pocket and, as soon as possible, make the investment.

Rangefinder

Again, we have already mentioned focusing and the need for some method of calculating distance. If you are not very good at assessing distances and you haven't got a rangefinder on your camera, then you need to buy either a tape measure or a separate rangefinder. Have a look at the different types and find one which suits you.

Haze filter

A haze filter will not help you take pictures in mist or fog. It will not even penetrate haze. What it will do is reduce the bluishness which often appears in distant scenes and even in close-ups taken on overcast days or in the shade. It requires no increase in exposure and a most useful benefit is that it can be kept in position permanantly to protect the lens. For this reason alone, it can be considered a useful accessory. Filters are made to fit lenses of various sizes, consult your dealer on the one suitable for your camera.

Tripod

Whether you need one or not depends on how steady your hand is, and whether or not you intend to take pictures in poor lighting con-

Some of the more important accessories which will help you make good colour pictures: (1) Cable release (2) Range finder (3) Haze filter (4) Close-up lenses (5) Lens hood (6) Exposure meter (7) Tripod.

ditions. If you do decide to buy one, buy a really solid, rigid type which will do the job properly. Most tripods have telescopic legs. Check them at full extension. If the legs are excessively whippy, don't buy. Also, if it seems excessively light, consider whether the first breath of wind will blow it over. If it might, then ponder the fact that your precious camera will take the full impact when it crashes to the ground.

Lens hood

A good lens hood can fulfil a useful service by preventing excessive glare reaching the lens and reducing the brilliance of your picture. If you take pictures almost straight into the sun, you will almost certainly need one to prevent sunlight falling on to the lens. A lens hood will also help to protect the camera lens somewhat by preventing spray, or rain from falling on it. Lens hoods are inexpensive items and it is a good idea to buy one with your camera.

Cable release

If you haven't got a cable release it's almost a waste of time using a tripod. A cable release is a flexible lead which screws into the shutter release button so that you can fire the camera without touching it. It is useful when you have to give exposures longer than $1/30$ second.

Close-up lenses

Close-up lenses fit in front of the lens of your camera and allow you to go closer than the minimum distance marked on the lens. They are available in three strengths but can also be used together to enable you to get within a few inches of your subject. If you have an SLR camera, you can see exactly what happens when you fit them. However, with any other type of camera you have to be extremely accurate with focusing, for at these close distances, depth of field is minimal.

Close-up Lenses	Focus Setting in Feet	Lens-to-Subject Distance in Inches*	Close-up Lenses	Focus Setting in Feet	Lens-to-Subject Distance in Inches*
+1	Inf	39	+3 plus +1	Inf	$10\frac{1}{8}$
	15	$32\frac{1}{4}$		15	$9\frac{5}{8}$
	6	$25\frac{1}{2}$		6	$8\frac{7}{8}$
	$3\frac{1}{2}$	$20\frac{1}{2}$		$3\frac{1}{2}$	$8\frac{1}{16}$
+2	Inf	$19\frac{1}{2}$	+3 plus +2	Inf	$8\frac{1}{8}$
	15	$17\frac{3}{4}$		15	$7\frac{3}{4}$
	6	$15\frac{1}{4}$		6	$7\frac{1}{4}$
	$3\frac{1}{2}$	$13\frac{1}{8}$		$3\frac{1}{2}$	$6\frac{3}{4}$
+3	Inf	13	+3 plus +3	Inf	$6\frac{3}{4}$
	15	$12\frac{1}{4}$		15	$6\frac{1}{2}$
	6	$11\frac{1}{8}$		6	$6\frac{1}{8}$
	$3\frac{1}{2}$	$9\frac{1}{4}$		$3\frac{1}{2}$	$5\frac{1}{2}$

Most lenses come with a suitable focusing table so that you can use them on cameras with separate viewfinders. The table above gives the distance you can expect when using 1, 2 and 3 dioptre lenses on any camera. However, before doing any really critical work, do make a few test pictures to ensure that everything works with your camera.

Making
Colour
Pictures

Up to now we have involved ourselves mainly with the technicalities of photography: choosing cameras, working out exposures and so on – we have hardly mentioned *creative* colour photography. There is a good reason for this. Without a certain basic technical ability you can't take much more than fairly simple snapshots. At the beginning of this book we said that colour photography was easy and we are not going back on that. Anybody can pick up a simple camera and, provided they follow their instruction book, produce reasonably presentable results. However, to produce pictures worthy of the name, you need to go beyond that stage, to understand what you are doing and why you are doing it.

Technical ability can be acquired by anybody prepared to spend a little time learning and practising; but to produce *real* pictures you need more than just technical competence. Pictures which are technically perfect are desirable, but unless they contain that vital spark of life, character or warmth, they are of little value. Technique for the sake of it is worthless. A good picture must do something to you, make you feel something, whether you like it or not is immaterial.

What makes a good colour picture?

That question should read "Who makes a good colour picture?", and the answer is – you do. It's obvious, really, for unless you actually press the button then there is no picture – good or bad. If you are the person who takes the picture then it is you who has the choice of making it a good one or a bad one.

There are no real qualities that necessarily lead to a good colour picture. So much is bound up in personal taste. We can make rules, of course, such as it must be sharp, or it must be correctly exposed and yet the next picture which makes us catch our breath in admiration is under-exposed and fuzzy. We can demand that the colour be perfect – and yet a good colour picture may contain hardly any colour at all – it may be comprised almost entirely of greys suffused with the merest breath of a pastel tint. We may ask that the subject be appealing – but what about those pictures which came from the war correspondents in Vietnam? They were magnificent pictures but in no way decorative. Even if we say it must be artistically correct – well, who specifies art?

One man's art is another man's junk.

No, in the long run it comes back to the person who takes the picture. He decides whether or not it is going to be good at the moment of taking.

Normally, we take a picture because we see something we like and wish to record. It may be a little girl playing on the lawn with her dolls, the magnificant arch of a suspension bridge, or something as simple as the reflections of coloured neon signs in puddles.

Whatever the subject, in most cases you want to record it, just as you see it, on colour film. What you have to remember is that the picture can never be quite the same as the subject you look at. However good your record turns out to be, inevitably it has certain limitations: it is stationary whereas the subject was probably moving; two dimensional rather than solid; it shows an isolated fragment of time, not a continuous existance. To make a picture which is going to appeal to yourself and your friends, you have to work within these limitations. You need to portray the movement, solidity and life which characterized the subject, otherwise all you get is a mere record – and not a very good one at that.

The first thing you need to do is to try and identify the factors which make the subject so appealing. This is easy when we are faced with, say, a pretty girl or a rugged mountain pass: but what about a busy market place, where smells and sounds excite, or a misty autumn morning with soothing silence and the softness of the air. Whatever the quality or qualities which attract you, pause and try to pinpoint them. Decide how best you can show them pictorially, for the qualities which attracted you are the ones you want to communicate. These qualities are the essence of the subject. There are four major factors which you can use to picture them:

1. Viewpoint
2. Lighting
3. Colour
4. Timing.

To a certain extent these factors are inter-related. For instance viewpoint may be affected by lighting conditions, or vice versa. Timing may very well govern the colours. However, to simplify matters we will look at them separately.

Viewpoint

Usually, when you come upon an appealing subject, the first instinct is to look through the viewfinder and press the button. There are, of course, occasions when this is necessary, even vital, otherwise you can miss the chance of a picture. More often than not, however, you have the opportunity to look more closely at the subject, move around and study it from different angles. It is surprising how often it turns out that the first viewpoint was not the best one.

Imagine the main street of a small fishing village with the harbour in the background. Coming upon it by accident, you are delighted by its antique character, the gaily-painted fishermen's cottages, the smugglers' inn, the blue-green waters of the harbour. Now, a quick look around before you take the picture. Yes, in fact you have only to walk across the street to eliminate the petrol station (which did nothing for the olde worlde atmosphere) and gain a point of interest. Tucked behind one of the cottage walls is an artist painting the scene. A simple change of viewpoint, like this, taking only a moment, can enhance the atmosphere in many scenes.

It is surprising how, simply by looking around, you can so often find an alternative viewpoint to improve the picture. The trick is in actually seeing what is in front of your eyes, picking out anachronisms (such as a modern garage in an old fishing village) and spotting details which help (such as an artist busy painting). Oddly enough, unless you concentrate, you don't normally take in a great deal of what you see. The fishing village, when you first come upon it, is simply too much. You get an overall impression of water, cottages, inn and street all bound together in a mass of colour. It looks an ideal picture. It is only when you stop and really look hard that you begin to notice the finer points – the honey-suckle climbing up the walls of the cottages, the dark oak of the ship's chandlery at the end of the street, the little boy fishing from the harbour wall. Perhaps more important in most situations is the exclusion of unwanted details – advertising signs, overhead telephone cables, power stations and the like can ruin an otherwise suitable scene. The problem is still there, but in rather a different guise, with subjects closer to the camera. Here you tend to see the subject with great clarity and ignore the background. How disappointing when an otherwise superb transparency is spoiled

because you did not notice that ugly, red-brick chimney dominating the background, or the pylon sprouting from the subject's nose.

Most people, too, see things only from eye level. Don't hesitate to think tall or think small. Visualize subjects from high up or low down, and if you decide that either of these alternatives will improve the picture, then do something about it. Getting down low is not difficult (even if it means lying in a puddle) and walls or steps often let you get higher. It is interesting to notice how a change of viewpoint (either up or down) can affect the subject. From low down the subject gains height and dignity, (and frequently allows you to use the sky as a background).

From high up, the subject appears smaller and the background opens up (it may avoid large areas of blank, boring sky).

Whatever the subject, a rugged coastline or the girl next door, it's often worth looking around for a natural frame. No, not the silver type which stands on the mantlepiece — it's too early for that — you want something which might naturally surround the subject. The seascape, for instance, might be photographed through the branches of a windswept tree. The young lady might smile to us through the lowered window of her car. A dark frame in the foreground adds depth to the picture and emphasises the brilliance and colour beyond. If possible, though, it should be kept dark or in shadow, so that it does not attract undue attention. At the same time, it should be recognizable, otherwise the viewers will be so busy trying to puzzle out what it is that they won't get around to seeing the subject it is supposed to emphasize.

One further aspect of changing viewpoint that you should consider is lighting. Simply altering the camera position from one side of a sunny street to the other can make all the difference between photographing the brilliant colours of a row of houses in full sunshine to photographing the subdued tones of a row of houses in deep shadow.

Whatever we do, it pays to think about viewpoint.

Lighting

It's surprising how many photographers, some of them quite experienced, believe that taking good colour pictures calls for bright

sunny weather. Perhaps this is something of a folk memory from the days when colour films were slow and needed a lot of light to provide good results. With modern films this is certainly not the case. It's true that strong lighting tends to make colours more brilliant (obviously the more light falling on them, the more light they can reflect) but sunshine isn't really necessary. In fact, one of the nice things about taking pictures in colour is that the tints and hues themselves are like a form of bottled sunshine which enlivens all the pictures we take.

Subdued lighting

You certainly need *light* to produce pictures but it doesn't have to be sunlight. Have you ever thought about taking colour pictures in bad weather? Look at it this way: a little earlier we said that to be more than just a record our photographs had to convey special qualities, one of these qualities is atmosphere. Suppose, for a moment, we wanted to take a picture of Stonehenge. Thousands of people visit the stone circle every year and bring back bright, sunny pictures. Most of us, however, when we visit the monument, are conscious of a pervading aura of mystery. There is a feeling in the air of drama – possibly even foreboding. Perhaps it is simply the legends we have heard about the place which give us this feeling. The point is, if we are going to make a worthwhile picture of Stonehenge, ought we not to get this atmosphere over in the print or transparency. How? Why not try waiting until the skies are leaden, the storm-clouds gathering. Then just before the storm breaks, if you are lucky, the clouds might part for an instant to allow a shaft of watery sun to pick out the stones themselves. This is an extreme example, and photographers are rarely as lucky as that, but isn't it food for thought? It's almost a hundred to one that the resulting picture would be more exciting than any of those sunny snaps. At least it will be different.

There is no doubt about it, far from being public enemy number one, given due consideration the weather can be our best friend. There are many subjects available only when the weather is wet. Rainbows, for instance, are ideal material for the colour photographer, and provide something of a challenge (see if you can work out how best to record them before we discuss them further on in this book). The important

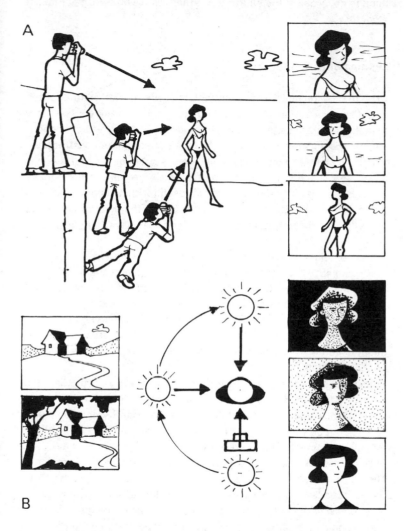

A. Before taking a picture, think about the possible effects of a change of viewpoint. A higher or lower camera position can often help isolate and concentrate interest on the subject. B. So also can a frame in the foreground. Changing viewpoint may also improve (or detract from) the quality of the lighting.

thing to do is look at the weather and then decide how we can make it work for us.

Lighting direction

Despite this, the majority of colour pictures are the better for a spot of bright sunny weather. When you do have sunshine ask yourself how to make the best use of it. Sunlight produces different effects depending on the angle at which it catches the subject. Simple instructions tell you to keep the sun behind you. There is good reason for this — it is a safe, sort of lighting, free from problems. Unfortunately, it is equally rather boring. It gives flat, textureless results with no shadows to add depth and solidity to the picture. Admittedly, the colours come out strongly and brilliantly, but overall, the result can be rather lifeless and somewhat uninteresting.

Better colour pictures can usually be made when the sun is to the side of the subject. Side lighting produces highlights and shadows which throw the subject into strong relief, emphasising its shape and roundness. Because it catches even small unevenesses, this sort of lighting not only imparts a more three-dimensional quality to the picture, it reveals minute textural details. The texture breaks up what might become broad areas of flat colour into more attractive patterns of light and dark.

Potentially the most exciting form of lighting you can use is back lighting, where the sun is behind the subject and shining towards (but not into) the camera. Colours take on what can only be described as a luminous quality impossible to achieve any other way and everything touched by sunlight is picked out with a beautiful glowing halo.

Side or backlighting makes photography somewhat more difficult. The contrast between the brightest lit parts of the subject and the deepest shadows is often greater than the film can manage. Exposure must be assessed either for the brightly lit areas or for the shadows, depending on which occupies the greater proportion of our picture (or contains the detail you want to record). Close up pictures may benefit by having light reflected into the shadow areas to reduce the contrast. This can easily be done using a white board or even a piece of newspaper. Except for special effects, you must prevent sunlight

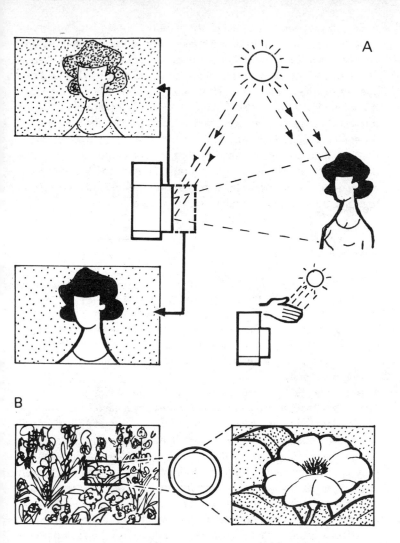

A. It is sensible to use a lens hood whenever possible — even if only for the protection it affords. A lens hood, or some sort of shield, is vital if there is any likelihood of direct light falling on the camera lens — use a hand or a piece of card, if necessary, to prevent degraded colours. B. In a garden filled with flowers use a close-up lens to pick out the brilliant colour and beauty of one individual bloom.

falling on the lens when taking the picture. Sunlight (or any other direct lighting) on the lens will make flare patches in the picture. These can spread to cover the whole frame and degrade the brilliance of colours. A lens hood, or even a hand held up to shade the lens can prevent this happening, but make sure the hand does not appear in the picture. With outdoor subjects, you have little scope for manipulating the lighting: but often you can wait for the right time. If the subject requires sunny conditions, try to decide from which direction would the sun be best shining. Perhaps you could come back at a different time of day or even a different time of year. Whatever the answers, you should never fail to make some sort of record even if you think you might be back to take another picture.

Colour

Although I have been involved with photography for many years now, I can remember quite vividly the first colour pictures I ever made. I was about fourteen at the time and had saved up hard to buy a roll of Dufaycolour. It took me months to use that film up – all eight exposures. I believed that every picture had be be packed with as many different colours as possible, otherwise I wouldn't have been getting my money's worth.

Most people feel the same way when they load up with colour for the first time (although not necessarily for the same reason). For some, it is simply reaction at being able to record in colour after years of working in black-and-white. To others it is the feeling that with colour film in the camera they must have colour to record. Whatever the reason, the effect is the same – each frame filled to overflowing with every different tint and hue. Unfortunately the result is nearly always disappointing. It's strange but true that the most colourful and exciting pictures are often the ones in which the photographer has been most economical in his use of colours – using two or perhaps three warm mellow tones with one flash of saturated colour to light up the whole picture. Maybe even a very few broad masses of contrasting colour to create a dynamic effect.

One of the best ways we can learn about the use of colour is to take a look over nature's shoulder. If you get the opportunity, slip away from

civilization for an afternoon and take a walk in some beech woods or down by the river (it will do you the world of good even if you don't succeed in learning very much). Now, just concentrate on looking at colour, and if you can find one note of discord, you can bet your boots it will prove to be man-made. In the beech woods, it's a world of rich browns, cool calming greens and, if it is spring, perhaps bluebells echoing the azure of the sky. Later on in the year, the emphasis has changed somewhat and what you see are warm golds, russetts and rich browns with here and there a flash of holly berries to provide a note of brilliant scarlet. When you walk beside the river in summer-time you again find some of the browns of the beach woods but lots more green as the fields and trees slip down to the river. Now you find there are splashes of yellow from the clusters of buttercups and this time it is the river which reflects the blueness of the sky.

Nature's colour schemes appeal to us all, perhaps simply because over centuries we have become accustomed to them. Always there are broad masses of colour, usually fairly neutral browns and greens. Here and there a flash of saturated brilliance as the holly or the buttercups provide a startling contrast. You can follow nature's example and echo her effects in your pictures — not necessarily using the same colours but by adopting the same principles.

Consider your own colour schemes. How does your use of colour compare with nature's? Your living room, your kitchen, the children's room — were they papered and painted in the first colours that came to hand? Or did you sit down, perhaps with others, and quietly work out what would look best in this room, what would provide a contrast there? Perhaps you haven't got quite so much to learn as you thought, for almost certainly your own sense of colour harmony and balance is already reflected in the wallpapers, paints and fabrics which you have selected to make your home a bright, cheerful and cosy place to live in.

What you have to do now is apply what you already know to your photography. Just as you wouldn't decorate your living room in-discriminately with a jumble of reds, greens, yellows, oranges, purples and pinks, so you shouldn't cram inharmonious mixtures of colour into your pictures. It doesn't work. It looks even worse than a thoughtlessly painted living room.

One of the problems we have to face when we discuss colour is per-

sonal taste. Everybody sees colour differently and has his or her own personal preferences and hates. What pleases you may send me rushing for cover. I may prefer bold, vigorous colours, you may prefer delicate tints and pastel shades. However, this is not too important. What we must agree on is that there always has to be order and a sense of balance. If they are to be successful, this order and balance must show in your pictures. To achieve the best possible results you have to be cautious and discriminating in your choice of colour, using it economically and thoughtfully. Don't just shoot whatever happens to be there (mind you, if you were taking a picture of a row of houses all with blue curtains except one which has pink, you may find some difficulty persuading the lady of the house . . .). You should consider mixed areas of colour carefully, asking yourselves are they attractive? Do they do an important job? Would the picture be better if they weren't there? Can you avoid them by changing viewpoint. Two or three related colours (gold, dark reds and browns for instance) together with one strong, contrasting colour (perhaps royal blue) can have more impact than a dozen assorted tints and hues which succeed only in making the eye wander from one to the other without giving it any one point of interest.

Consider, for a moment, a garden. In it are masses of flowers – roses, chrysanthemums, clematis. It's a riot of colour and your first reaction is to lift the camera and shoot. It's a mistake and it's all too easy to make. The finished picture would be a jumbled mass of colour with no point of focus for the eye. Select instead just one or perhaps two flowers and photograph them against a green background of leaves or the rich brown of the earth and the result will be a really dramatic picture. As always, one or two colours, well chosen, can have a far greater impact than an assortment of different colours.

Let's take a look now at some groups of colours and see if we can the effects they have on us. Most people, whether they like a particular colour or not, still associate certain feelings with it. Some idea of these associations will help us plan our pictures better.

White

White is coolness, freshness, spaciousness and cleanness. A girl in a summer dress, a brand new fall of snow. A large area of white sur-

rounding any colour makes that colour appear more brilliant and more saturated, but also smaller than it really is.

Black

Large areas of true, really empty blackness seldom *occur* in colour photography. There is usually some detail to be perceived somwhere. The effect of blackness in colour pictures is not to give an overall feeling of gloom and despondency as one might suppose. Instead, it throws up the brilliance and luminosity of the colours which appear with it. It tends to make any area of colour which it surrounds appear larger.

Black and white are the ultimate in contrasts. Together with grey, they will make the most of any colour appearing with them. Pictures comprising mainly blacks, whites or greys with perhaps one single colour can pack a tremendous punch and can appear (oddly enough) more colourful than pictures showing a variety of bright colours.

Red

Golden yellows, oranges, reds and browns are all related in that they each contain some proportion of red. Red itself is a warm and irrepressible colour – it dominates and tends to advance to the forefront of our picture, giving the impression that it is larger than it really is. Avoid letting red creep into a picture unless it has an important part to play, for it is never suitable for a subordinate role. Like a good-looking girl it immediately attracts the eye. Yellows and oranges also attract attention in a picture. They are sunny and lively. Browns, on the other hand, are mellow, more quiet and restful. Because they are all related, these colours fit together well and give a feeling of unity to a picture.

Blue

Blues, blue-green and purples are also related – in their blueness. They are cool, receding and give an air of spaciousness to a picture.

Because they don't attract attention to themselves, as the reds do, they are ideal background colours (but that doesn't mean they *have* to be relegated to the background). Used extensively, they can create a feeling of quiet and restfulness in a picture. They mix well and, used together, give unity to a picture.

Mixing them

What happens when we use different colours together — for instance reds with blues, greens with yellows? After all, we are told that some colours clash and we know that many colours harmonize. To my mind, our own sense of propriety will tell us whether we are achieving a desirable effect or not; and provided we give ourselves time to consider the merits of the combination we should be prepared to back our own judgement. Really, nobody can lay down rules and regulations. All that can be offered are guidelines. Fashions change, tastes in colour change and what has been acceptable for years will, all of a sudden, no longer apply. The best we can do is take knowledgeable advice, use our own discretion, and shoot.

Timing

Timing can be the split-second that makes all the difference between a superb action shot of a hawk catching its prey and an empty picture. It can also be an average picture now as opposed to a superb picture in three months time when the sun is shining on to a cathedral tower at just the right angle. Timing is knowing exactly when to squeeze the shutter release.

The first sort of timing involves anticipation and quick reaction that you are likely to learn only by experience. It is usually only when you look at the results that you can tell if you made an exposure either a little too late or a little too early. Sometimes you have to shoot, as it were, from the hip and hope for the best because the subject (particularly if it is the hawk after its lunch) is not going to wait while you check the exposure and focusing. In situations like these you can only do your best and hope to achieve some sort of result. A suitably preset

exposure and distance setting can improve your chances. On most occasions, you have some sort of foreknowledge of what is going to happen and can prepare accordingly. For instance if you are trying to get a picture of two young children playing, you can have everything set up – exposure and focusing adjusted – but you still need to be spot on with your timing. If you miss the crucial moment you can hover patiently for ages and may not be lucky again for the rest of that day. To get an outstanding picture, you have to be alert and waiting – anticipating so that at just the right moment you can release the shutter. You can learn split-second timing, but it needs patience and lots of practice.

There is, however, another sort of timing which is important and it is learned a lot more easily. All it requires is serious and thoughtful consideration of the various components of your picture before you actually make the exposure. Imagine for a moment a harbour filled with fishing boats; it is quiet, peaceful and the water is calm. The viewpoint is right, the lighting is good and the colour is perfect – what more can you want? Well, perhaps a little action. Perhaps there is a fishing boat tied up at the jetty which shows signs of life. Should it cast off it will have to move straight through the picture, adding just the right touch of life and sparkle to a scene which might otherwise be somewhat static. All you have to do is wait.

Never be in too much of a hurry to take pictures unless a delay is likely to lose the picture. It will pay you to look around and consider the effects of waiting – even a few moments – until perhaps the sun comes out from behind a cloud or goes in; until that orange cement lorry moves out of the picture, until some hikers fight their way along the cliff walk to show just how blustery the weather really is. It may be worth waiting hours to get the shot you want. For example, the calm peacefulness of a harbour may best be conveyed at the end of the day, when the sails of the fishing boats are silhouetted against the setting sun. It may even be worth getting out of bed a little earlier next morning, to capture the scene when a soft mist blends sea into sky without a join and the flaming colours of the previous day are transformed into pastel shades.

There is one other aspect of timing which is important and it is most likely to crop up when you are relaxing on holiday. You might be tempted when you see a picture to put off taking it until tomorrow, or

to leave photography till next week. Don't. It might be raining, the scene may have changed, the people you wanted to record might not be there. If now is the right time, do it now.

These, then, are the factors you really ought to consider as you prepare to take your picture. Most of these tips are only common sense and would probably occur to you anyway. As for the others, it's surprising how, after a little bit of practice, they become second nature, and you find yourself automatically taking a half-dozen steps to the side to make use of some overhanging branches or waiting until the lady in the orange dress and pink cardigan moves out of your picture.

Colour photography is a wonderful pastime inasmuch as it is full of surprises. You can never be quite sure of what you have recorded on your film until you actually see the prints or transparencies in front of you. A quickly taken snap, shot almost without thinking, can turn out to be the prized item of your collection — simply because everything happened to be right and going for you at the time. On the other side of the coin you can work for hours on a picture, composing it, getting the colours which harmonize perfectly, waiting until even the rain is at precisely the angle you want it — and it just doesn't click.

Whatever you do, don't give up. Read these pages and try to make use of the advice wherever possible. Don't worry overmuch if you miss things, if people are in the wrong place or if the lighting is wrong. Practice makes perfect and the only way you will learn to make good pictures is by trying to make good pictures. And for you, good pictures are the ones you like.

Looking
for
Subjects?

Hardly a serious question. When you become the proud owner of a camera which is not only reputedly capable of producing sharp, clear colour pictures, but, after the first few trial rolls, obviously does so you are unlikely to need to search for pictures. The difficulty is in restraining your itchy shutter-finger. Potential pictures are everywhere: in your home, at work, in the park, at the shops. Subjects are all around you: you have your family, your friends, your pets, your garden.

Half the fun of making colour pictures, though, is in the planning. Anybody can go trotting around with a camera taking photographs of everything in sight, the real test is when the results come back from processing. Are they exactly what was wanted, or do they fall somewhat short of perfection. Think about the subjects you intend to take and plan how you intend to take them. You can not only save a lot of money and avoid a good deal of disappointment, but also really begin to feel you are creating something.

In the next few pages, we'll look at some of the subjects you might wish to photograph. We'll consider some of the best ways to approach them, offer a few tips along the way and a little advice on how to avoid some pitfalls. Don't take the advice as gospel-truths – it isn't; it's simply *my* approach to subjects. It may help you, it may be just what you need – I hope it is. But, if it doesn't work for you, then don't hesitate to do things differently. The important thing is to plan in advance – that is really the secret to successful picture-taking. The rest is up to you.

Children

Children are the most rewarding camera subjects of all, particularly if they are your own. You can have fun talking to them, playing with them and – when you finally get around to it – taking their pictures. No matter how bad your pictures might be, there is always somebody, somewhere who will enjoy looking at them – because they like children. However, although they can hardly ever be photographed badly for they are supremely photogenic subjects, it can still be extremely difficult to take *really* good pictures of children. They think fast, they move fast and suddenly they're gone; so, be on

your toes; be prepared to work hard, use a lot of film, and above all, enjoy yourself.

You are most likely to take pictures of your own youngsters and this can give you a big advantage. If you start taking pictures of them when they are babies and carry on from there, they get used to having a camera pointed at them and don't pose specially for it; normally they carry on with what they are doing leaving you to get some great pictures. Even if you produce the camera and say "now look, I want to take some pictures of you doing this" then, provided "this" is interesting, they are usually quite willing to co-operate – (unless they are already doing something even more interesting, like reading a comic or going to the toy shop).

If you can't gain their attention you can either resort to bribery, or, sigh patiently and wait awhile. The wisest course is the latter for, no matter how you try to bribe pre-occupied children their minds will remain on what they would have been doing had you not interrupted them.

As you know if you have children of your own – you must treat them as people, not necessarily as children. They are intelligent, thinking people but many photographers miss this point and so lose out. Don't talk down to children. They will know and the loser will be you.

It used to be the thing when photographing youngsters to dress them up in their Sunday best, scrub their faces and sit them down with a stern "be quiet and sit still".

Happily we are beginning to realize that is is just the wrong thing to do if we want to get natural, unposed pictures. Children don't normally sit around quietly in their best clothes – they play football and look after rabbits; they put their dolls to sleep and dress up as nurses; they pick daisies and climb trees. It's no use trying to get them to conform to your ideas of what makes a good setting. You have to get up and follow them.

If you have ideas, tell them what you are trying to do. They know you want pictures and they like to see pictures of themselves – but they don't enjoy wasting good playing time sitting down with polished faces while Mum fusses with a hairbrush and Dad tinkers with his exposure meter. Don't forget, too, that they are just like you – they have their off-days as well as their on-days. If they are feeling a bit under the weather, don't harrass them just because you have a fresh film

in your camera, or you want to use up the last pictures on a roll. It won't make them feel any better and, worse still, it might put them off acting as your models in the future.

Start soon

As far as taking pictures of children goes, the best time to start is at the beginning. Babies are probably the easiest to photograph for they stay still, they don't take up poses and they are not camera-shy. Why not start at the hospital a day or two after the birth? Begin now and you have the basis of a complete record of the child growing up. Use a fast colour film. If you are lucky and find that the ward has large windows and afternoon visiting, there may be plenty of available light for you to take your pictures using daylight-type film. Watch out, though, if you are using available light, for mixed lighting. If there is any sort of artificial lighting on in the ward, you may get some rather weird colour casts. You can, of course, use flash. There is a story that flash can harm a young baby's eyes, but this is not true and you need have no fears about using it.

Do be careful not to irritate the hospital staff, or the other patients. If you are in any doubt, ask for permission or for help.

Babies grow up quickly. Make sure you get plenty of pictures along the way. It's no exaggeration to say that every fortnight sees a change and with colour film you can record it.

Lighting

The best sort of lighting (for all ages, really) is soft daylight when the sun is hidden behind hazy clouds. This type of lighting is gentle, without the harshness of full sunlight and warm, without the blueness of overcast weather. Pictures out of doors are always easier to manage than those taken indoors. If the sun is too brilliant, use a white paper reflector to shine a little light into the harsh shadows. If the child is in the pram, put a white or cream canopy over it and let the sunlight filter through that. Don't use a coloured one, though, or the baby may look a funny colour in your picture.

If your home is fairly light, with big windows, there is every chance that you will be able to take some pictures indoors using daylight. You'll want a camera with a wide-aperture lens and need to be careful with your focusing because there won't be much depth of field; but you should be rewarded with some excellent pictures.

The next most convenient method of lighting is flash. Use blue flashbulbs, flashcubes, magicubes, or electronic flash and you can use daylight type film without any filters. If you want soft lighting, something akin to diffused daylight, try bouncing the flashlight from the ceiling or even from a spead-out newspaper (see page 158). Take the distance from the lamp to the reflector and then to the subject as the total distance when you are working out your exposure and open up ½ − 1 stop to allow for the light which is absorbed by the reflector. Remember that, unless it has an independent light sensor, you can't use a "computor" flash gun on automatic when you are bouncing the light.

However you arrange your lighting, the important thing is to make sure you get plenty of pictures. Bathtime, mealtime, trips out − then, of course, the first few steps. All these are opportunities which you must not miss, for, once missed, they are lost forever. Make sure you go in close. Babies are tiny and when they are wrapped up in cot blankets and shawls they can tend to disappear.

Backgrounds

Backgrounds are important, too. Particularly as you are making your pictures in colour. Wherever possible, try to arrange a plain, un-cluttered background with no startling reds or oranges in it. These colours always push forward and try to steal the limelight. When the children are in their normal surroundings, indoors or out, playing with toys, make sure the background is reasonably tidy. Try to keep their bright things between them and the camera and watch out for everyday objects as well. It's amazing just how obtrusive a chair leg, dustbin or gatepost can be when you get the picture back.

Don't forget your old ally, depth of field. Open up your lens as wide as possible while still maintaining a reasonable zone of sharpness to allow for them moving backwards or forwards. This not only softens

the background and throws the youngsters into sharp relief, it also lets you use a fast shutter speed to "freeze" any sudden movements – and there will be many of these.

Toddlers are very little people and when you are taking pictures of them it pays dividends to get down to their level – meet them eyeball to eyeball, so to speak. There is nothing undignified in getting down on all fours with your camera, in fact it's quite fun. The trouble is, it's so much fun you often don't get around to taking pictures. Keep checking the focus when you are moving around a lot and you are working close in, a few inches either way makes all the difference between a crisp, crackling, pin-sharp winner and an out-of-focus also-ran.

The right film

Before you start your photographic record, pause a moment to consider what material you intend to use, whether colour negative or colour reversal film. You may be a colour transparency enthusiast but, don't forget, you are likely to want to keep some sort of album of pictures of the new arrival and for an album, you need prints. You can of course get prints made from transparencies but, if you want high quality, you pay a lot and, if you don't pay a lot, the prints are seldom as good as you would hope. A better idea might be to use colour negative materials almost exlusively for your family pictures and have prints and/or transparencies made only from the better ones. This way you can be selective and keep the cost down as much as possible. You don't have to get them all printed. Some firms will just process the film, and make a contact sheet (often only black-and-white) of all the negatives. Then you can choose the ones for printing. It pays to ask around for just the service you want.

As we said before, babies grow up quickly and while this makes some people sad, others are inclined to breathe a sigh of relief. Either way, it happens quickly and, unless you get your pictures as each step forward is taken, then those moments are lost in the past forever. Always keep your camera loaded with the right material and handy so that you can grab it when an opportunity arises. The time to make the record is now, next time is always too late.

Portraits are an exciting type of colour photography. Soft lighting is best, perhaps from a reflector or an umbrella flash – *Pat Walmesley.*

Pages 98 and 99: Holidays usually turn up a multitude of colourful subjects, not least of which are national costumes. Don't overlook those of your own home country, though – *Jeff Bawcutt, R. K. Dunkerley.*

Page 100: It's difficult to take a bad picture of a child. This one was taken indoors using daylight coming through a window.

Page 101: An imaginative fantasy shot taken quite simply with one flash unit off the camera – *Peter Styles.*

A dark subject against a brilliantly-lit background. Exposure is critical if you want a good picture – *Nedra Westwater*.

Opposite: Make sure you provide an attractive background for your subjects. Here, the flowers match almost perfectly the pinks in the swimsuit – *Michael Barrington-Martin*.

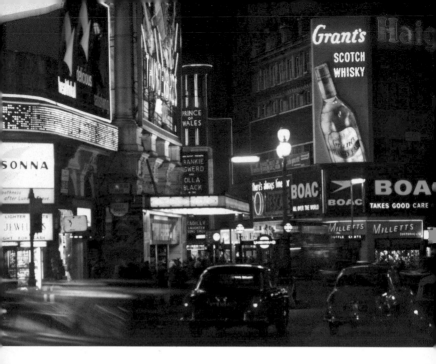

Night shots in colour can be taken by anybody. There are no strict rules regarding film, exposure or types of lighting.

Page 104: Pictures can turn up at the most unexpected moments. It pays to have your camera always at the ready.

Page 105: Portraits don't have to be confined to those of human beings. Try going in close. How intrepid are you? – *Sid Emery*.

Opposite: Look for the unusual – like this piece of modern sculpture. Wait until the lighting is right – and you have a ready-made picture – *Neville Newman*.

Just to prove that really good colour photography is not confined to experts, we thought we would show you these two. The picture above was taken on a simple cartridge-loading camera by the author's eight-year old daughter.

This superb into-the-sun shot was taken from an aircraft by a twelve-year old, again with a simple camera — *Sarah Bradney*.

Remember, colour pictures can be taken anywhere. This shot was taken deep down in a cave, using the single electric light which was available. A snap shot made quickly using a guessed exposure.

Page 110: Go in close for really dramatic shots of flowers. Use a steady support and remember the parallax problem. Notice how this picture is almost all one colour, like the sculpture on page 107 *– Neville Newman.*

Page 111: Although you are using colour materials, your pictures don't have to show every hue in the rainbow. This shot is subtly striking for its monochrome simplicity. A star filter has been used to good effect *– Kodak.*

As children get older life becomes even more hectic. There are trees to be climbed and ponds to be fished, dolls to be dressed and hop-scotch to be played. Summer and winter alike, the activities continue – and so should you.

Changes in the seasons bring changes in atmosphere and colour to your pictures. In summer you have swimsuits, summer dresses and bright shirts. You have parks, fields, flowers and beaches. In winter you have gaily-coloured scarves, football kit and bobble hats. You have snowmen, skating and party dresses. You have children all over the place, not just your own but everybody else's it seems. Don't be too selective. Photograph your own children by all means, but photograph them with their friends, too. They are all part of the process of growing up and they will all become part of the memory.

Events

Photograph the birthday parties. First of all waking up, finding the presents, the greetings from Mum and Dad. Then photograph the party itself – the arrival of guests, the blowing out of candles, the games, musical chairs, hunt the slipper, statues, all the eternal, everlasting standbys. Hope for a bright sunny day for pictures outside, but have your flashgun prepared just in case it isn't. Picture them at Christmas decorating the tree, hanging paperchains, stirring the pudding, addressing cards. And make sure you photograph them with seldom-seen relatives who come for the festivities.

Take pictures of them watching television – when they are rapt in the excitment of a film with eyes only for the screen. Take pictures of them painting; show the brilliant colours on the paper (and on them) and, if it's good – photograph the painting itself. Photograph them on the beach, building sandcastles, eating ice cream. Don't be selective about activities, but be selective about the pictures. Each time you press the button, try to make a good picture – remember the backgrounds and the colour contrasts, wait for exactly the right moment.

Try taking a portrait every birthday – an official portrait but taken in an unofficial way. Full length, perhaps, in a long party dress or a cowboy suit, but not stiffly posed – relaxed instead and doing something they

enjoy. What about sitting playing the piano or astride a bicycle. Move in closer for a head-and-shoulders portrait. For a little girl why not try something clever like photographing her combing her hair in the mirror (this is tricky as far as focusing goes – it is the distance from the camera to the mirror plus the distance from the child to the mirror. In other words, the reflection is as far "behind" the mirror as the child is in front of it!). Watch out that you don't catch your own reflection, though, when you are trying this one out. For a boy, why not leaning over a wall, or out of a window.

Action

Test your abilities to the full by taking some action pictures. Picture the children running, jumping, climbing, cycling. This is the way to get life into your picture. You don't need a fast shutter speed (although it helps). Read the section on action pictures (page 127) and then try it out.

Try taking a sequence – for instance a game of leap-frog. A scene-setting shot of the group preparing for the game; a fairly close shot to show the determination on the jumper's face as he prepares to start running (waist upwards would do); a faster action shot of the runner on the move, broadside onto the camera (getting him all in); the actual jump (showing both figures); and finally, with luck, both parties falling on the floor to end the sequence.

There are lots of little stories you can tell in this way. Let the kids in on the idea and they'll fall over themselves (literally) to help you. Give them colourful clothes to wear and pick a day when it is bright and sunny. This lets you use a fairly fast shutter speed to stop action as well as a smallish aperture to give you lots of depth of field. You also get brilliant pictures full of saturated colours.

Assistance

Often it helps to have someone with you; to hold the flash, or spare lenses; to get a drink here or an elastoplast there; or just to aid the children in your aims. However, make sure that whoever helps you

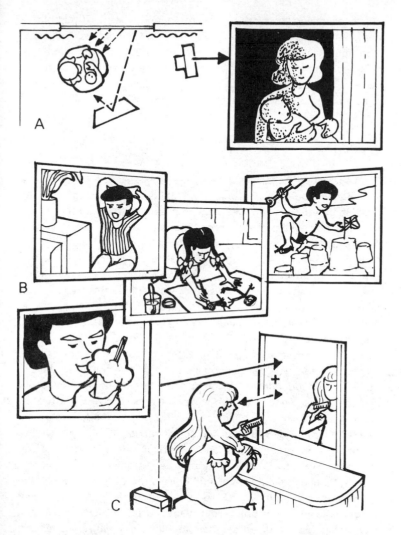

A. For first pictures of mother and baby in hospital, use a fast colour film, position them near a window and use a card reflector. B. Make imaginative pictures of children *doing* things. C. Mirror shots make unusual pictures. But the focusing is a little tricky, you must add the camera to mirror distance and the mirror to subject distance to get correct focusing distance.

knows exactly what you are trying to do, and what you want him or her to do. It doesn't help if you have to argue about details. Also, try to stop your helpers, or any other onlookers from "encouraging" the children. Cries of "look at the camera", "come on smile", "push your hair back", "sit still, it won't take long" and so on coming from various directions are not likely to help your picture taking.

People

People fascinate people, that's why they make such popular camera subjects. If you find photographing children rewarding, then try thinking of adults as grown-up children — for that's what they are. If they are doing something which interests them they're happy, if they're treated politely they're usually co-operative, and if they're having an off-day then you might as well forget photography. Adults can be more difficult to photograph than children because they are often camera-shy and self-conscious. To balance this there are an awful lot of people about who love having their photograph taken; you'll find them at home, at work, having fun or simply doing anything that people do.

You will probably start by taking pictures of close friends or members of your own family. This is a good idea for two reasons. First, you can build up your confidence; experiment with posing, lighting, exposure and camera angles to your heart's content, and nobody will be too upset if you have one or two failures. Secondly, your model knows you and will, one hopes, be helpful and co-operative.

If you are photographing just one individual, it is a good idea to go somewhere quietly where you won't be disturbed. It's a mistake, usually, to take other friends or relations along with you "to watch the show". Invariably, they will come up with "helpful" ideas and suggestions which you don't really want and, unless you put at least a few of their ideas into action, there are likely to be hurt feelings and atmospheres which help nobody — least of all, photographer and model.

Try to get away from the formal approach, if you can. We've all seen pictures of Uncle Bill standing stiffly to attention in front of the camera and, really, you can do something better than that. Try giving

the person you are photographing something to do – for instance outdoors, someone could be looking at a map, or holding a camera, picking a flower or opening a gate. They are less likely then to look conscious of the camera.

Unless they are born models, most people feel a little bit awkward when they are being photographed. Hands and feet grow to twice the size and it's a problem to know what to do with them. Don't let it be your subject's problem – make it yours. If your model is at ease you'll find it much less difficult to photograph him or her. Try giving a girl something to hold in her hands and look at – a seashell, if you are on the beach, perhaps a leaf if you are in the country. A man usually feels more relaxed if he is sitting (on a wall perhaps) or leaning against a fence with his hands in his pockets.

Be ready

When you are taking portraits of people, make a point of working out and setting the exposure well before you start. Then, unless there is a disastrous change in the weather, forget about it. Nothing is more calculated to ruin the composure of a person being photographed than having the photographer run backwards and forwards waving an exposure meter at them. If they know what it is, you will simply keep breaking their concentration; if they don't know what it is they may think that they are the cause of your trouble and that will really unnerve them. If you need to check the exposure level, then be fair to your model and call a five minute halt to the session to give you both a chance to unwind. Don't ruin a fast-moving session, though, just because the sun happens to move behind a cloud. Open up one stop as the light goes and close again as it re-appears. You can learn to do this without even looking away from the viewfinder. Practice when the camera is empty and you'll find that it becomes second nature very quickly.

Of course, it isn't necessary to set up a photographic session simply to photograph a person. You can often get much better pictures of them as they go about their normal routine or are busy with their hobbies. If your father is a keen gardener, try taking pictures of him as he tends his orchids in the greenhouse, or plants a rose in the border. Take pic-

tures of your wife sewing or making a cake in the kitchen. When people are doing things which are familiar to them and which they enjoy doing, they spend less time worrying about how they appear to the camera. They are more relaxed and sure of themselves and this comes over in the pictures.

Look around

Of course, there are lots of interesting people outside your immediate circle and you won't want to restrict your picture-taking to family and friends forever. Take a stroll through a fairground and look at the people who are there. The men and women who run the sideshows encouraging people to spend their money and in return, have a little fun; they put a lot of effort into their work and are worth spending some time and film on (and, if they are helpful, why not take a few turns at their stall?). Snap the folks who are enjoying the rides; try a shot of the happily-horrified faces of the ghost train passengers as they burst back into daylight. Photograph the spectators who wouldn't ride the roller-coaster even if they were paid to. Take a trip to an open-air market and photograph the sellers and the buyers. Go to an open-air election meeting when feelings are strong, record the hecklers and the heckled.

Sometimes it is a good idea to ask people to co-operate when you are taking pictures; other times it is better to remain as inconspicuous as possible. This is something you will have to decide for yourself. Most people are prepared to co-operate happily and will help you as much as they can, providing you don't catch them at an inconvenient moment. There are problems in taking this course of action though. Frequently people tend to put on an act as soon as they realise they are being photographed; others object strongly to the very idea. You are not allowed to take pictures on private property without permission, so be prepared to ask. In public, there is nothing to stop you picturing anybody — legally. If you feel you can take their pictures unobtrusively and without them being upset should they find out, then this is probably the best way to go about it. The important thing is to avoid hurting folks and causing trouble or embarrassment.

Unobtrusive photography

You might think it impossible to remain unobtrusive when you are hopping around with a camera, taking pictures – well, of course, it is if you are really hopping around. Try instead to merge into the background. Move quietly and slowly and don't constantly make adjustments, changing lenses or checking exposures. If you can, fit your camera with a long-focus lens so that you can stay well away. Of course, you must not use flash – this would give you away immediately. When there is no chance of being unobtrusive, say at a party, or photographing people working, meeting or enjoying themselves, it often helps if you tell them quite simply that you will be taking pictures – lots of them – and it would help you if they ignored you completely. They will usually do so and you will get some really good pictures.

It's always a good idea to load up with a reasonably fast film and also with as long a length of film as you can. This way, you can still keep shooting – even in poor lighting conditions – and you don't have to keep stopping to re-load. Although it may sound expensive, to get the really good shots which are characteristic of the people you are shooting, you are going to have to use a lot of film. Make sure you have a good supply near at hand and then get down to shooting, shooting and shooting.

Remember the colours

Never forget that you are shooting in colour. Be on the lookout for colours in the background which are going to clash with the colours worn by your subject. Be on the lookout, too, for odd colours reflected in the skin tones of your subject. If you are photographing a girl in a blue sweater, it is quite possible that the blue will be reflected into the shadow area under her chin giving her a very ugly "five-o'clock shadow". Before long, you will find that noticing these things soon becomes automatic, something which you do almost without thinking.

119

Animals

Flaming red setters, silver-blue persian cats, luminous-pink flamingos, fluorescent-green fighting fish; have you thought about it? The world of birds, animals and fishes provides a wealth of colour just waiting for your camera.

To photograph animals successfully, there are two things you need to have. The first is a liking for them, the second is plenty of patience. If you don't have these two characteristics, then it might be a good idea to find another subject, but then, if you don't have these characteristics I don't suppose you'll read this section anyway.

Make no mistake about it, animals are extremely difficult subjects to photograph well. If you have any doubts at all, then try telling your cat to move just a little to the left, please. However, if you meet the challenge successfully, then you can consider yourself a member of an elite; for few photographers can photograph animals successfully, consistently.

What sort of animals will you want to photograph? Well, why not start with domestic pets; they are usually easier to handle and are in some cases more biddable then wild ones. There are the obvious ones, of course, the cats and dogs, but many more besides and one can add to the list, mice, gerbils, hamsters, fish, cage birds, rabbits, tortoises and a host of others.

Whichever of these animals you decide to photograph, it is useful if you have somebody around to help you (preferably somebody known to the pet concerned). Most animals like to move about, some of them fairly quickly, and a companion can help keep them amused and oc-cupied at about the right distance from the camera. Even a tortoise can prove awkward, not only by withdrawing into its shell, but by determinedly turning its back on the camera. It helps if you have somebody there to turn it around again. Before you start, tell your helper exactly what you are hoping to achieve; then, with any luck, you can work together to produce the desired result.

Dogs usually enjoy a romp, and the secret of success is to decide beforehand where you want the animal to be when you photograph it and the exact spot you want to photograph it from. Mark these two locations and then you can set the focus and get on with the job. (Make sure you select a good position with regard to lighting and

background, of course.) Your helper can now start playing with the dog, making sure it remains close to the spot you have marked. A dog playing can move extremely quickly, so use a fast shutter speed and take plenty of pictures. If you want a rather easier life, wait until the animal has had its meal and is washing or, perhaps, dozing with one eye open. Alternatively, get your helper to groom the dog or put it through an obedience routine of the "sit", "stay", "beg" type.

Cats move more slowly and in a far more dignified fashion. You quickly get to know their habits and you can catch them at just the right moment. Try picturing them when they are lying sunning themselves, relaxing on the rug in front of a warm fire or stalking in the garden. Kittens, like dogs, enjoy a lively game but they, of course, are not quite so wild. Here again your helper can come in useful; this time with a bright red or yellow piece of paper on the end of a string or a similar plaything. Alternatively, have a little boy or girl cuddle the kitten in their arms — this always produces an attractive shot. Don't overlook your pets' special habits: they can make really good pictures — and be just a bit different. Perhaps your cat opens the shed door, or your dog tows a child's tricycle. Don't however try to make them perform special tricks just for your camera, this hardly ever works.

Small animals

When you are taking pictures of small animals such as kittens you need to go in really close. It's suprising how easy it is to be too far away without actually realizing it. Make sure you fill the frame as nearly as possible. Exclude anything which is not part of your picture so that all the interest is on the animal you are photographing. Get down to the level of the animal even if it means lying on the floor. Mice, guinea pigs, gerbils and even cage birds are best photographed in their home surroundings. If you can, take the front off their cage or house — replace it with a sheet of glass, if necessary (but watch out for reflections) and then take your pictures.

There is one problem which arises when you are taking pictures of small creatures at close distance with flash; that is that the light is too powerful and you can't stop down far enough to prevent your picture being overexposed. If this happens, you need to cut down the amount

of light from your flash gun. Simply drape one or more thicknesses of ordinary household tissue over the front of the lamp. The amount of light lost depends on the number of tissues you use. You will need to experiment, of course, to find the number of tissues you need to use with your own particular flashgun, but once you have a reliable formula you know it will stay the same. One point you must remember though, before you try to make use of this technique – use only white tissues. If you use pastel-tinted ones you are effectively illuminating your subject with coloured light and this can look very odd in the finished picture, unless you really do want to picture pale green mice.

Fish

Fish are not as difficult as you might first think, and you can soon take exciting pictures. Fish of all kinds, but particularly the tropical varieties, make wonderful subjects for the colour camera. They are graceful, beautiful and often brilliantly-hued. Marine tropicals make especially attractive subjects, but even the dullest fish has a superb sheen to its scales and delightfully luminous eyes. Before you begin to take your pictures, ensure that the water is clean and that the front of the tank (through which you will be taking the picture) is free from algae. Don't try to take pictures of fish in bowls. The results won't please you and they certainly won't flatter the fish. If you look at a fish in a bowl, you can see that the curvature of the sides of the bowl causes distortion which would spoil the picture completely.

To take colour pictures of fish in an aquarium you will need to replace the existing illumination with more powerful lighting of your own. Probably the easiest form of lighting to use is flash. You can use it from the camera position or, more naturally, pointing down into the aquarium from above. To ensure even illumination over the length and depth of the tank, make sure the flashgun is at least two feet above the surface of the water. If you can, extend the sides of the tank upward with white card and put a roof on it to reflect all the light downwards. Of course, you don't have to use flash; you can use photoflood or tungsten lights in exactly the same way. Remember, though, to use the correct film (type A or B) or, alternatively, the correct conversion filter with daylight film or you will get a strong

A. Use backlighting to add sparkle to a kitten's fur, but don't allow the exposure meter to be fooled by all that light from the windows. A reading from the back of the hand will give the correct exposure. B. Use a telephoto lens to obtain a larger image when the subject is shy. C. A close-up lens will help you make good pictures of tiny pets (watch out for parallax). Cut down the intensity of a flash by covering it with layers of tissue and angle it down slightly to ensure adequate coverage.

yellow cast in your pictures. Another two points to remember if you are using high-powered photographic lamps for any length of time – first, they will heat the water, perhaps to the detriment of the fish; second, they will shatter if they inadvertently get splashed.

If you are using a light from the camera position, take your pictures at an angle to the front of the tank. If you stand directly in front of it, the glass will act just like a mirror and the light will be reflected right back at the camera. Some fish are quite tiny creatures and dart about extremely quickly. This means that you will have to go in quite close – perhaps with a close-up lens – and so depth of field will be rather restricted. To avoid having to constantly alter focus and getting so frustrated that you eventually deposit the camera in the tank with the fish, you can restrict their movement. Get a sheet of plate glass which is just slightly smaller than the side of the aquarium through which you are taking pictures. Put this in the tank, on its edge, and move it slowly towards the front of the aquarium to trap the fish and restrict the width of their swimming space to about two inches. This makes it a lot easier to photograph them sharply. Obviously, it is only kindness to remove the glass immediately you finish your picture-taking.

Birds

Moving outside the home to photograph wild birds and animals adds a completely new dimension to your picture taking, and to be really successful needs some specialist knowledge of the creatures you are photographing. Of course, this doesn't apply to the wild birds that come into your garden. Most of them are quite small and to achieve worthwhile results you need to use a telephoto lens on your camera – preferably at least a 200 mm lens on a 35 mm camera to get an acceptably large picture. However, provided you own a lens like this, you can have an awful lot of fun for the cost of a packet of bird seed.

Captive animals

Zoos and wild-life safari parks provide magnificent coloured animals and birds in quantity and also lots of pictures for your camera.

A. Tropical fish make superbly-coloured subjects. Use a sheet of glass to keep them within your depth of field. With flash on camera, avoid reflections by taking pictures at an angle to the tank. Better still, light from above. B. For captive animals, use wide apertures and get in close to make cages vanish.

Nowadays, whenever possible, the animals roam fairly freely in large areas. So it is quite easy for you to photograph the animals in surroundings which look fairly natural. If they are in a cage or pen, you can often simply photograph between the bars. If that is not possible, you can eliminate the bars or the netting by putting the lens as close as possible to it. It is then thrown so far out of focus it actually disappears. Be very careful, however, that you are not putting yourself in a position of danger by going too close. It is only sensible to take heed of warning notices that are about — they are put there for your benefit, after all. While we're talking about safety, too, remember that when you are driving through a safari park and you are supposed to have the windows of your car closed, it is asking for trouble to open them — even if you do feel you can get clearer pictures by doing so. The thing to do is make sure that all the windows are spotless before you set out — then you are left free to take your pictures.

When you have to take pictures through glass — of any sort — always get your camera lens as close as possible to it. This ensures that you won't get reflections in the picture and, like the cage netting, any specks of dirt are so out of focus they just won't show. With captive animals, it is an advantage, but not a necessity, to have a telephoto lens. With it you can obtain otherwise impossible close-ups of the animals. How do you fancy taking a head-and-shoulders portrait of a Bengal Tiger with a standard lens?

When you are photographing animals in cages, you usually have to use a fairly wide aperture because of the poor lighting conditions. So you need to focus accurately. This has a rather happy side effect: it gives a more-or-less out of focus background.

What about film

It doesn't really matter what sort of pictures you are taking — whether children, grown-ups, animals or anything else — it pays in terms of picture quality to use the slowest colour film you possibly can.

Obviously you have to take into account the sort of pictures you are going to take, the lighting conditions that you will encounter, the shutter speeds and aperture you hope to use and then, on top of this, decide whether you need to allow for any contingencies which may

arise. I always feel it is rather better to err on the side of safety and have a little extra speed in reserve for the time the unexpected occurs. Oddly enough, it's always the occasions that you haven't got that extra bit of film speed that the unexpected does choose to turn up.

Sport

Taking pictures of fast action — sporting pictures in particular — can be fairly straightforward if you have a camera with shutter speeds of $1/250$ second or faster. You simply point the camera and take the picture, (make sure that you press the button just before the action you want). This gives you quite acceptable pictures, but they are not always the *best* pictures. The trouble is, when a picture is taken using a very high shutter speed (or with electronic flash) any movement is frozen — the subject is sharp, the background is sharp — the whole thing could have been set up and posed specially for the camera. To give a realistic impression of movement in a photograph, there usually has to be some blurring. You can get that by using slower shutter speeds — giving an exposure which doesn't quite stop the movement.

How you introduce this blurring, how much of it there is and what shutter speed you need depend on the sport you are photographing. Let's take a look at two rather contrasting sports, motor racing and golf and see how they might be tackled.

There are two ways of photographing a car moving across the field of view of the camera and indicating that it is moving. You can hold the camera still and take your picture just as you see the car appear in the viewfinder. Use a shutter speed $1/60$ or $1/125$ second, and you have a picture of a very streaky something crossing a very sharp background. Alternatively, you can pick up the car in the viewfinder and swing the camera to follow it. Keep the car centred in the finder and press the button just as it passes you. This is called panning. If you pan carefully and follow through, you will have a sharp picture of a racing car moving across a very blurred, colour-streaked background. The way you do it is up to you. Both will be pretty colourful pictures, but only one will show a recognisable car. The shutter speed you use when you are panning depends on how skilful you are. It could be as low as $1/30$ second but for starters, try about $1/125$ second and work

down. The slower the shutter speed, the greater the impression of movement but the more difficult it is to capture the subject sharply. Taking a picture of a golfer as he makes his drive, where the main movement is confined to only parts of the subject – the arms and the club – requires different thinking. A lot will depend on the sort of picture you require.

There are three ways of doing it and at the same time suggesting motion. You can photograph him the instant before he makes his stroke, when he is completely still. There will be no blurring in this picture. The tension in the player's face and body will be sufficient to suggest the movement to come. A second method is to use a shutter speed of about $\frac{1}{250}$ second and photograph him in mid-swing. This will stop the motion of body and shoulders, but the arms, hands and club will show as a gradually increasing blur, reaching its peak at the end of the club where movement is at its fastest. The third method is similar to the first. Photograph him at the end of his swing, with his eye on the ball and his arms and club stationary at the top of the stroke. Again, no blurring but plenty of tension.

Both the first and last shots could be tackled (after a bit of practice, perhaps) with shutter speeds as low as $\frac{1}{40}$ second. The important acquisition in all sports photography, though, is a good sense of timing – learning to choose *exactly* the right moment to press the shutter release.

Using a simple camera

As we said earlier, stopping action with high shutter speeds doesn't present a lot of difficulty, but, supposing your fastest (or only) shutter speed is, say $\frac{1}{60} - \frac{1}{80}$ second. What then? Well, one way to photograph fast-moving subjects with slow shutter speeds is to choose a position where they are coming towards you – or moving away from you (which is, probably, less exciting but perhaps safer). This minimises the effect of the movement and can look dramatic. Distance also makes a difference. The further you are away from your subject, the slower the shutter speed required to stop the action. This doesn't work of course if you have a sophisticated camera and use a long focus lens to enlarge the subject, you just bring the movement back again as well.

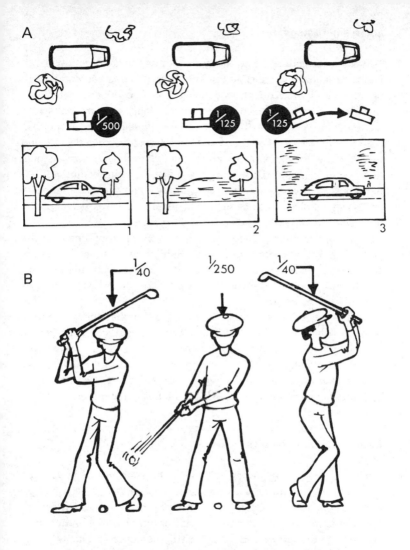

A. Use a fast shutter speed to stop subjects moving *across* the field of view or, to obtain maximum dramatic effect use a slow shutter speed and pan the camera. B. Sometimes there is a dead point where movement stops, before beginning again. At this point, very slow shutter speeds can be used. Sometimes even a fast shutter speed will fail to stop action, but the resulting blur can add impact to the picture.

Learn where to go

To take successful sporting pictures a lot depends upon how much you know about the sport you are photographing. If you know a fair bit about the sport in question, you will be able to work out the points at which drama will be high but movement fairly slow, and take your picture at these points. For instance, in a cycle race you could choose a point near the top of a steep hill where the riders are really working hard, but are not moving too rapidly (incidentally even a small, local race provides an amazingly colourful subject for your camera).

If motor sport is your forte, then why not try to get into or near the pits and take your pictures close up as the drivers pull in for fuel, or as the mechanics and managers discuss performance.

At an athletics meeting, the runners can be photographed on the blocks the instant before they start. High jumpers and pole vaulters can be stopped in mid-air at the dead point – that is, the point at which they stop going up and start coming down – but this does require a fair bit of practice.

At football matches or other team games – netball, hockey, etc. – watch for the moments when play stops momentarily. Look for the moment when the player with the ball stops and feints – notice, too, how the players around him freeze. Take pictures of the goalkeeper tense and still before a shot on goal. Don't forget the crowd – often the most highly coloured part of a football or rugby match.

Choose suitable fixtures

If you are "somebody" connected with the sport or game, you can find your way to a good viewpoint at a major event. Otherwise, you may well find that the smaller, local events provide you with more opportunities for your picture-taking. At important, national meetings, you tend to be part of a jostling crowd. The action is usually a long way away from you, often moving away from the camera rather than towards it and, frequently, the camera angle is wrong – all problems over which you have no control.

At smaller meetings, however, whatever the game, the action remains the same as in the bigger events and may even be more live-

ly. Better still, you can usually roam around and, with a bit of luck, choose the position where most action is likely to occur. You may even be lucky enough to be able to compose your pictures — for instance, get down really low and use the sky as a background, or frame the shot through a goalkeeper's net. Whatever you do, don't get in the way of the participants, officials or the specators; they turned up to enjoy the sport — not to provide you with pictures.

While we are on the subject of sports and games, don't forget the indoor varieties such as table tennis, badminton, snooker etc. Unless you have a really wide-aperture lens you will have to use flash to get pictures at all. Electronic flash certainly stops the action, but this does sometimes tend to kill the atmosphere. Bulb flash gives you about 1/30 second, although you can use higher speeds on some cameras. So

SHUTTER SPEEDS NEEDED TO FREEZE MOTION

Subject	Approx. Speed MPH	Camera-to-subject distance	Motion at right angles to camera	Motion at 45° to camera	Motion toward or away from camera
Swimmer	2–3	25ft	1/125	1/60	1/30
Rowing boat		50ft	1/60	1/30	1/15
		100ft	1/30	1/15	1/8
Sailing boat	3–9	25ft	1/250	1/125	1/60
Horse walking		50ft	1/125	1/60	1/30
		100ft	1/60	1/30	1/15
Cyclist	8–15	25ft	1/500	1/250	1/125
Runner		50ft	1/250	1/125	1/60
Horse trotting		100ft	1/125	1/60	1/30
Athletics Horse racing Motor boat Driving Football	15–30	25ft	1/1000	1/500	1/250
		50ft	1/500	1/250	1/125
		100ft	1/250	1/125	1/60
Motor car	over 30	25ft	1/1250	1/1000	1/500
Motor cycle		50ft	1/1000	1/500	1/250
Train		100ft	1/500	1/250	1/125

you may want to use bulbs just to allow you to show some movement. Don't blithely flash away, though, without warning the competitors or, if it is a commercial venture, obtaining permission beforehand. That is to court unpopularity and, maybe, risk assault if somebody is put off their stroke by the flash.

Swimming is an indoor sport which can provide plenty of brilliance and action for your camera, particularly if you attend the galas which are presented for the benefit of local schoolchildren. The best position is high up looking down on the pool. For diving, however, you need to be low down and to the side of the competitor. Watch for splashes on the camera lens, though. You may not notice them until too late and by then they will have ruined your picture. If you use the existing lighting, you must match your film to it. Tungsten lighting is usually acceptable with type B transparency film, or with colour negative film. Fluorescent lighting is difficult with any film, but one or two manufacturers do supply possibly helpful filters.

Holidays

Many photographers take more pictures on their annual holiday than all the rest of the year. The reasons for this are not hard to find – there are different surroundings, new friends and acquaintances and the general feeling that one should be recording a high spot of the year. Everybody takes pictures of the family and friends on the beach, outside the hotel or the tent. They also take general picture records of the locality, so although these are important reminders and shouldn't be forgotten why not try something different next time you go away.

Even before you go, you must lay the foundations for a successful expedition. The first thing to do is find out as much as possible about the area you intend to visit. You may have friends who have been before you – they will be only too happy to have the opportunity to tell you all about their adventures, their impressions of the place and show you the pictures they took on their visit.

Try, too, to get hold of books or tourist guides which will give you inside information about the buildings, the countryside and the people – the local library is a good source. The information you collect will not only give you some ideas of the sort of pictures to take, it will give

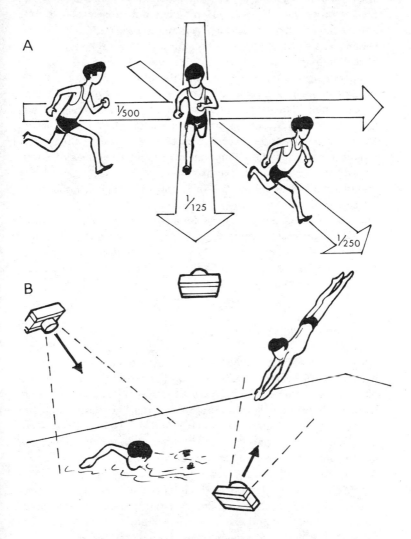

A. If you've only got a slow shutter speed you can still get sharp pictures of athletic events by ensuring the direction of movement is *towards* you. B. Camera positions are limited at the swimming baths. Choose the best one for the action you are photographing.

you a lot of background knowledge which may well be useful when planning trips out. This way you may find out about places, people and events you might otherwise have missed seeing.

When you are packing for your holiday, don't make the fatal mistake of putting off buying the film until you arrive at your destination. It's disappointing to find when you get there that you can't get your favourite material and you have to make do with something different. Apart from this, life is always a bit hectic when you first arrive and you invariably end up by putting off buying film till later and so miss out on lots of good pictures. For this reason pack plenty of reels, cartridges or cassettes of the film type you prefer and at the same time, consider whether you should take one or two packs of a faster material or a Type A or Type B Film for those low-light or indoor shots which are bound to turn up.

If you have not used your camera for a while, make sure it is in good working order before you go. It's a simple matter to run a reel of black-and-white film through it; you don't need to have prints made, the negatives will show up any defects which are not obvious from just handling the camera.

The journey

Another mistake best avoided is that of packing your camera with the luggage, partly because you feel it might be safer and partly because you're certain you won't need it on the journey. Won't need it on the journey? Don't you believe it. There are as many exciting pictures to be taken on some journeys as you will find in the entire first week of most holidays, so always keep your camera close at hand (but safe in its case until you need it) wherever you go. If you are travelling by air, it is worth finding out beforehand whether your baggage will be checked by X-ray equipment. Although harmless to people, some of this equipment may cause fogging of film. If you have spent a great deal of money, time and effort in trying to produce worthwhile pictures, there is no point in having them ruined unnecessarily.

Let's now concentrate on the business of taking pictures.

Start with the journey itself. Begin with some pictures taken at your point of departure of the boat, plane or train which whisks you on your

way. Maybe you're not travelling in such exotic fashion. Record then the overloaded motor cycle or perhaps the even more overloaded rucksack with boots beside it.

If you are on an aeroplane or in a train, you may be tempted to take pictures through the window. This is a good idea and will work, provided you don't rest your camera on the window ledge or on any part of the vehicle. If you do, vibration from the engine or wheels will be passed to the camera and your pictures will be badly blurred. Exciting pictures can be taken from the plane as it is coming in to land or taking off. Usually, the plane banks one way or the other to give you a better, if more nerve-racking, view of the world beneath you. Try to include part of the wing in your pictures to give some impression of scale and angle. Look out for spectacular cloudscapes and sunrises and sunsets which are a must for your collection. When you take pictures from a moving vehicle, always use the fastest shutter speed possible.

Arriving

Arriving at your destination, you will almost certainly be excited and impatient to look around. At this stage more than any other you may be inclined to look upon the camera around your shoulder as something of a nuisance which can easily be used tomorrow, or the next day or the next. After all, you have the whole holiday before you with plenty of time in the days ahead for picture-taking. Be careful. It is very easy to fall into the trap of leaving everything until the last few days and then finding the weather has deteriorated, or your itinerary has to be changed. It is sound practice to take your pictures as and when you see the subjects before you; this way, you make sure you have them on film. First impressions are important, too, and things that strike you when you first arrive may tend to be pushed into the background later in your holiday.

Broad views

Landscapes or seascapes play a major role in holiday picture-taking but you can, occasionally, run up against some problems. Earlier in

this book we mentioned that a valley or a mountain range can look awfully impressive when you are actually standing there looking at it, but in a tiny slide or print all the drama is lost. Some of the impact can be regained by projecting the slide or having an enlargement made, but the best way to ensure that people realize the magnitude of the scene is to put a person in the foreground. This adds an element of scale, and folks looking at the picture can judge the dimension of the mountain or valley by comparison with the figure. Dress your model in a bright warm colour such as red or orange and see how the picture takes on an almost three-dimensional appearance.

A precaution which is often worth taking when you are making pictures of landscapes or seascapes is to use a haze filter over the camera lens. You can get one to fit almost any modern camera and it cuts out the bluish cast which often appears in pictures of scenery even on apparently clear days.

Lots of subjects

When you are on holiday there are always pictures to be taken – local monuments, buildings, family and friends, scenery – these are the sort of pictures that everybody takes and rightly so. They are records of your holiday and they mustn't be forgotten.

However, try to take some pictures which, while still characterizing your holiday, are a little more out of the ordinary. Look for instance for the coat of arms of the town or district you are visiting. You may find it beautifully worked on one of the doors or gates to the Town Hall, so why not take two pictures? One of the building in its entirety and a close up of the coat of arms itself. You may, too find this device flamboyantly displayed on the public transport, in brilliant hues. Here again are two pictures; one close in and one pulling back slightly to show, not necessarily the whole bus or tram, but at least some of the passengers. Look up and around you at the, possibly, unusual shop or inn signs. Will these help to convey the colour and atmosphere of the place you are visiting?

Often, the posters outside cinemas and those advertising cigarettes and other goods can provide gaudy, colourful and informative pictures for your camera. Street lamps make delightful and unusual sub-

A. Photography from a moving vehicle calls for a steady camera position. Don't lean or rest the camera on the sides of the vehicle or you'll get blurred pictures. B. Taking off and landing usually provides good aerial pictures. Include part of the aircraft to lend depth to the view. C. A figure in the foreground of a scenic picture adds scale and perspective. The effect is enhanced if the figure is wearing bright, warm colours.

jects, particularly those older ones suspended from buildings at street corners, and the ones which light a pathway across bridges and along embankments. Photograph them on daylight or artificial light film at twilight when they are first switched on and there is still colour in the sky. Give a variety of exposures — one or two stops more and one or two stops less than the exposure you think is correct. That way, you are sure of capturing the right mood.

Shop windows

Shop windows can offer a variety of goods, some identical to those you see at home, others so different it is hard to believe they are real. If you see a window which is filled with exciting and exotic wares, why not photograph it? It is as much a part of the place you are visiting as the seafront or the market square, and a busy shop window has its own story to tell.

Beware of reflections in the glass. Move to a point where they interfere least with the window display, and take your picture at an angle, so that you don't include your own reflection. If you really want to cut out all reflections use a polarizing filter. On the other hand, you may like to include the reflections of people actually looking in at the goods. Either way, you can make some attractive pictures. Shop windows are often brightly lit, sometimes with tungsten lights, sometimes with fluorescent tubes and sometimes with gaily coloured spotlights. Tungsten lamps, as we have said before, give a strong yellowish colour to your pictures. In the case of a shop window this warmth can often look attractive, but you may wish to use a filter or artificial light film to avoid it. Fluorescent lamps, on the other hand, are a bit of an unknown quantity. The results they give can vary from green to pink. Daylight film may give best results but it is often worth shooting no matter what film is in your camera. Coloured lamps and spotlights obviously throw pools of light of different colours. So you can go ahead and take your picture without worry. Nobody is going to criticize an exciting shot on the grounds that it was lit by red, blue and green lights.

Another subject which you may well come across on your holiday and wish to photograph is illuminations at night and the pictures you want

A. Develop an eye for colourful and telling details—the crest on the gates of the stately home, the symbol on the side of the bus. B. A polarizing filter is a useful addition to your armoury: It can cut out irritating reflections and give you maximum colour saturation.

can vary from a floodlit statue to the whole of Blackpool with its neon signs, fairy lights and illuminated tower. Don't be afraid of this type of shot just because it is night time — it is easier than you think. We won't cover it here, because we go into night shots in detail on page 152.

People

Wherever you go for your holiday, the one common and most fascinating element is the people you meet. Whether it is the New York cops, the yashmak'd ladies in the Souk, the regulars in a highland bar, or your fellow mountainers who cast their spell over you, you will want to remember them. Make sure, then, that you get some pictures of that friendly farmer you met at work in his fields — and don't forget a close-up as you chat to him. Photograph the old man playing boules on the sidewalks in France. Take a quick snapshot of that beautiful, immaculate air-hostess who shepherded your family on to the plane. Record the tourists who gaze in wonder at the Parthenon or in rapture at Buckingham Palace. They all help to make your holiday the success it is and they all offer you holiday pictures which are lively, cheerful and different. Remember though, it often helps if you ask people whether they mind having their picture taken — particularly if they are going to feature prominently. Few will object and most will be positively helpful, but, in some eastern countries, the inhabitants regard the camera as something evil or frightening and it would be wrong (and perhaps dangerous) to photograph them against their wishes.

Take care with composition

One of the tendencies when you are away and enjoying yourself is to spend less time composing your pictures. You may perhaps be less careful about ensuring that they are taken from the best angle, that the colours are right and that there are no offending objects in the background. This isn't unusual, it's all part of the general headiness which affects you when you are enjoying yourself.

The trouble is, it's only later, when you are at home projecting your

slides or looking at your prints that you notice the things which are wrong, the petty aggravations which could have been put right if only a little more time had been spent when you were taking the shots — just a little more concentration. Unfortunately, at this stage it can't be put right. The holiday is over, the picture's there and the opportunity for re-shooting gone, perhaps for ever. So, although time is precious and family and friends tell you to get a move on, do make sure you look just a little more carefully and think just a little bit harder about the pictures you are taking. It will cost only seconds more and it will make both you and your family a good deal happier when you are viewing your pictures at home during the long winter evenings when holidays seem so far away.

Out of
the
Sun

Up to now in this book we have weighted the balance heavily in favour of outdoor pictures. There are good reasons for this. Outdoor pictures in general are much easier to take, they can be taken with simpler equipment, and they call for no special filtration or decisions as to whether to use a photolamp - balanced film or a tungsten light-balanced film.

However, nobody wants to be restricted all the time to pictures out of doors. There are wet days spent indoors when the children are simply demanding to be photographed. There are the night clubs, visited on holiday, where the atmosphere is intimate, the people are friendly and the artists exotic. There are the cathedrals and public buildings with their superb architecture — inside as well as out. There are a thousand-and-one subjects hidden away from the glare of the sun all waiting for you to come along and photograph them.

Pictures indoors can be taken in a variety of ways. You can provide your own illumination using photoflood lighting or photolamps, you can use flash or, perhaps best of all, you can make use of the light which is actually there. Let's look at existing-light photography first of all.

Existing-light pictures

Existing-light photography means taking pictures by the light that happens to be there already illuminating the scene you wish to photograph. It can be produced by candles, high-powered spotlights, daylight coming through a window, street lighting — in fact it is any lighting natural to the scene. Because broad daylight is the normal photographic source it is not considered under the special category of existing light. Existing light photography is great fun. It has its problems of course; one has to make decisions as to which film to use, how to assess exposure etc. but these are more than counter-balanced by the fact that the pictures produced are realistic, natural and, most important, different.

Some pictures can't be taken any other way. For instance, a fountain, illuminated by coloured spotlights from underneath the water must be taken by its own lighting. Flash, or any other outside illumination, would kill the colour effect. You might just as well take the picture in daylight.

Indoor events, such as ice shows, indoor cycle races, weddings in church, and so on also need existing light photography. Not only might flash not be permitted, but, even if it were, the light would not carry far enough. (Incidentally, if you are intending to take pictures on occasions such as these, do ask permission from the people responsible for organising the event. Very few theatres, for instance, permit members of the audience to take pictures).

To take existing-light pictures, you really need a camera which, as well as having a fairly wide aperture lens — perhaps *f* 2.8 or wider, also has a range of slow shutter speeds —1— ½ — ¼ — ⅛ — ¹⁄₁₅ second and "B" (which allows you to keep the shutter open as long as you wish) are useful. If you have these, then your available light picture-taking is virtually unlimited. However, even with a lens aperture of *f* 5.6 and no slow speeds, provided you have "B" you can still take a wide range of pictures. Whatever your camera, it is a good idea to carry a tripod. You may not need to use it (you may not even be able to use it if there are lots of excited people around); in many cases you can find some suitable support for the camera but it's almost certain that the one time you haven't got it is the one time you will need it. Another useful item is a cable release. In fact, without a cable release it is often a waste of time using a tripod.

Films

If you use negative film, you have little choice of speed, but for transparencies, choose a high speed material. A colour film rated at about 160–200 ASA is ideal. There are faster films on the market or you can have existing films "push processed" to a higher rating. However unless you really need the extra speed, it is best to leave them for extreme circumstances when, whatever the conditions, you just have to get a picture.

As you know, colour films are designed to be used under specific lighting conditions. If you use a material designed for daylight under artificial lighting conditions, the results you get will show an incorrect colour balance — the picture will be too yellow. Similarly, an artificial light film will give you washed-out blue-coloured pictures in daylight. To obtain the most correct colour rendering, therefore, you need to

expose your film under the lighting conditions recommended by the manufacturer. The trouble is, when you are taking a picture of a street at night with neon signs ablaze, spotlights shining, fluorescent light in the shop windows and orange sodium street lamps on – how do you know which is the correct film to use? All these different types of illumination give off light of a different colour, so how can any one type of film be right for all? The answer is, it can't and this is one very comforting piece of information because it means that you can virtually use any type of film without worry. Personal preference is the deciding factor and the best way to decide your preference is by making tests. Artificial light materials (type A or B) would probably give the most correct results, day-light materials giving more yellowish but perhaps even more pleasing pictures.

Where people feature prominently in your pictures, the story is rather different. People expect flesh tones to look like flesh tones and if they don't, then your picture will be criticized for looking unnatural. You should make an effort, therefore, when people appear prominently in your picture, to try to match up the film to the light source. Sometimes this is easy – if you're taking a picture of the kids indoors with daylight streaming through the window then you use daylight type film. What happens however, when the light source is a candle? Not so easy. But when you think about it, candlelight gives off yellowish illumination, so the film to try first would probably be one balanced for tungsten illumination.

Fluorescent lights

One type of illumination which can cause problems is fluorescent lighting. The colour of the light given off by a fluorescent tube does not have the same effect on the film as it does on the eye. Although you see one colour, the film sees a slightly different one. There are also many types of fluorescent tubes – warm white, cool white and even some intended to look more or less like daylight. A good basis for trial is simply to use daylight type film and see what sort of results you get. If they are too green, try using a pale magenta filter, but this will require some increase in exposure.

Let us now take a more detailed look at some of the existing-light, picture-taking situations which may attract you.

At home

Probably the easiest way to start taking existing light pictures is at home using the daylight coming through the windows. You can use daylight film, which you probably have in your camera anyway, and the lighting is often reasonably bright. Make the most of it by drawing back the curtains as far as possible; this also helps to make the lighting more even and less contrasty than it might otherwise be.

Even when you are taking pictures indoors, the weather has to have its say. The best sort of lighting occurs when conditions are slightly overcast; this provides a softer, more diffuse illumination. When the weather is sunny, the lighting can be very contrasty. If the sun is shining away from the window, it might not be all that bright either. If you want a subject in full sunlight, choose a camera angle which shows the minimum shadow or, better still, position a piece of white card (or even a newspaper) so that it reflects some light into the shadow areas. Be careful though, because if you reflect too much light, the result can look a little odd as if there were two conflicting light sources.

An interesting type of shot, particularly if you have full-length windows, is to position your subject in front of one and make a picture of them in silhouette. Focus on the person, expose for the scene outside and use a fairly wide aperture to limit depth of field. Don't forget if you are taking a conventional non-silhouette picture and there is a window or other light source in the picture, your exposure meter may well be influenced by it. Take a reading close up to avoid this happening. A problem which may arise when you take pictures indoors by daylight is that the results may look rather bluish. This occurs when the weather is fairly clear and the sky is blue. To prevent this happening use a haze filter to warm the picture up slightly.

In the evening, you can take pictures by normal room lighting (use a tungsten-light (type B) film unless your rooms are lit by fluorescent tubes). Switch on as many as possible. This will cut down the length of your exposure times and soften the illumination generally to give a more pleasing effect. The best type of lights to use are ordinary table lamps or standard lamps with fairly translucent shades. Avoid pendant fittings alone as they tend to cast heavy unpleasant shadows (although you can use a reflector to soften them). If you have

household spotlights, use them to concentrate interest or pick out details. Make sure that they don't appear in your picture, though.

Even on tungsten type film, you get rather yellow results. These can often be improved by slight over-exposure. Cds exposure meters tend to over-react to tungsten lighting, and often your best exposure is that for a film which is slightly slower than the one you are actually using. For example, if you use a 500 ASA film, try setting your meter to 400, or even 320 ASA.

Avoid having your sitter positioned near a lamp and in front of it. Unless you illuminate them separately, the face will be in heavy shadow and interest will be concentrated on the lamp. It is much better to arrange the lighting so that it falls on the front or side of the face.

Interiors away from home

Once the bug for taking existing light pictures bites you, you will never tire of looking around for possibilities – not that you have to look very hard – they're usually there begging to be taken.

Consider your own locality for instance. There is the local itself, with its cheery atmosphere (getting smokier and more "atmospheric" as the evening wears on); bottles with coloured labels, mirrors and Victorian woodwork, perhaps; or, if you're lucky, real oak beams. Photograph the landlord, early in the evening before too many customers arrive, master of all he surveys. Then, later, deep in conversation with his regulars. Photograph the barmaids, hard at work and also being "chatted up". Perhaps there is a game of bar billiards in progress or some good-natured rivalry over darts or dominoes. There are pictures upon pictures to be taken; the difficult part is stopping yourself. Use tungsten light film – and don't forget to hold the camera steady.

Take a trip down to your civic centre, town hall, museum or art gallery (but check that they allow picture taking), not necessarily to photograph the exhibits, but to record the interior of the building itself. Most communities pride themselves on the outstanding architecture of their public buildings, sometimes with good reason. A point of interest often missed is the ceiling. Everybody looks around,

A. Harsh, directional lighting can be softened by the use of a reflector. Make sure it's a white one, though, or your model will take on the colour of the material you use. B. A flash unit on the camera can cast an unpleasant harsh shadow behind the subject. Raising the flashgun above the camera and moving it to the side can often lose this shadow, and give you a more attractive picture.

but many of us forget to look up. Probably the easiest way to take pictures like this is to lay the camera, on its back, on the floor, pointing up; you can pre-set it, pre-focus is and then, preferably using a cable release, take the picture. Alternatively, if it has one, let its delayed action mechanism release the shutter. Watch that nobody steps on it, though.

Frequently, the lighting in large buildings like this comes from fluorescent tubes — often augmented by daylight coming through windows. Use daylight film for best results.

Churches

Churches and cathedrals can be a photographer's dream, providing a storehouse of subjects for photography.

Allow plenty of time, not just to look around and take the odd pictures here and there, but to meet the challenge that some of these subjects will provide. Stained-glass windows make exciting colour slides and are not as difficult as you might imagine. Take a meter reading close in so that the meter reads only the light coming through the window and, to make sure the result is what you want, take two more pictures, one at one stop over and one at one stop under.

The lighting in most churches is a mixture of daylight and tungsten. Where there is only a very small amount of tungsten illumination in your picture use daylight film, otherwise use type B film.

Once again, don't forget to ask permission.

Entertainments

Shows and indoor sports are the sort of subjects which, if you don't take them by existing light, you will simply never get. Normally, at these events flash is not permitted, but, even if you had a ringside seat, you would need an extremely powerful flashgun to cover the distance between the performers and yourself. If you have a long-focus or a telephoto lens, take it along with you, then, as well as covering the whole, or most of the arena with the standard lens, you can use the long-focus lens to get close-up shots of the performers.

One of the headaches that comes with photographing shows, circuses, ice shows and the like is that unless you use an extremely fast film you can't use very fast shutter speeds and yet there is an awful lot of action taking place. At this stage it pays to remember the advice we gave you on page 128 regarding stopping motion. The thing to do is watch for the right moment. There are lots of occasions when everybody is still or almost still, perhaps singing, or poised ready to go into the next routine.

Make use of these moments, be ready to catch them, and you won't need a shutter speed higher than $\frac{1}{30}$ second. Don't forget the dead points where motion is at a minimum. For instance just as one trapeze artist reaches the end of his swing and is held by the next before they swing back together. Remember, when the movement is across the camera, you can pan, move the camera smoothly, following the action with the performer centred in the viewfinder. All these tricks help you when you have to rely on a slow shutter speed. It pays to practice them, until you know you can get a successful picture almost every time.

Of course, the ideal situation is to see a show twice – the first time to take stock, the second to take pictures. This can lead to excellent pictures but is, unfortunately, somewhat expensive.

Usually the lighting at shows and indoor sports is tungsten, but you may well find fluorescent lighting at sports arenas and carbon-arc spotlights (which are rather like daylight in colour) at ice shows and circuses. The choice of which film to load up with, therefore, is a matter of personal preference. Probably the best bet is to load up with daylight film. This will cope well with most fluorescent lighting or spotlamps and you can accept the yellowness of the tungsten lighting where it occurs. In theatrical situations such as this it seems more natural to have pictures which are on the warm side rather than cold blue images.

Once again, don't forget a very important point. The rest of the audience paid to see the show, not to be distracted by an enthusiastic photographer, bobbing about taking pictures. Take care not to annoy other people or interfere with their enjoyment of the performance for, if you do and somebody complains, the organisers may well decide to put a bar on photography – and that wouldn't help you or other photographers in the future.

Outdoors at night

Pictures taken out of doors nearly always give a good return for the time you spend on them. For one thing, you can get away with a lot because exposures are not critical nor is the colour balance of the film you use. For this reason, the odd mistake here and there usually passes unnoticed and, on some occasions can even turn out to your advantage.

Probably the best time to take night shots is at dusk before darkness actually falls. This often gives you opportunity to include some rich, and sometimes quite beautiful, colours in the sky. At the same time, the shops, the signs, the car lights and the street lamps are all on and you may get really magnificent pictures. It can be difficult to assess the correct exposure in these circumstances. Over-exposure will give more detail in the shadow areas and less in the highlights, whereas with under-exposure the effect will be just the opposite. However, only extreme over- or under-exposure will produce results which are completely unacceptable.

Although the majority of light sources in use after dark are tungsten, it doesn't really matter too much which type of film you use. Many photographers prefer to use daylight film because it gives warmer, more pleasing colours. The thing to do is try both — and decide which you prefer.

Christmas can be a good time to go snapping after dark. Look for the shopping streets hung with lights and decorations — and then try to stop yourself working your way through a whole cassette of film. Save some pictures, instead, for the shop fronts with their festive window displays and brilliantly-lit Christmas trees. The only problem here is that Christmas is usually rather chilly. Try to find a warm pair of gloves thin enough to allow you to operate your camera.

Incidentally, don't worry too much if you have to give long exposures and people and cars go past. Often, particularly if they are dressed in dark clothes, people won't even register on the film, or if they do, are simply ghosts passing in the night. Cars, on the other hand, with their white, red and orange lights leave brilliant trails of colour which can well enhance your picture.

In the summer, many public buildings, floral gardens, statues and fountains are floodlit — particularly in holiday areas. The difference

between the daylit scene and the night-time view is often remarkable, occasionally worth a shot of each. At night include people, trees or even a statue in silhouette in the middle distance or the foreground, or try to frame the scene by an archway or doorway. It may sound a little like setting black against black but it works and it can create atmosphere and add a three-dimensional quality to the picture. Make sure the people are fairly still, though, if you want them to register sharply because unless you have a very wide-aperture lens you will need a long exposure time.

Fairgrounds

One of the most exciting subjects for the camera at night is the multi-coloured, noisy, frenetic world of merry-go-rounds, helter-skelters, sideshows and amusements that go to make up the modern fairground. Photograph the ferris wheel, black against the twilight sky, with its multicoloured lights shining like bright stars. Wait until it has stopped and passengers are alighting, one car at a time, then make the picture. Try it again, this time moving. Use an exposure time of perhaps $\frac{1}{2}$ second or longer to make it a whirl of colour. Photograph the water chute as a car hits the water, from in front if you want it fairly sharp, otherwise from the side, with the car a blur of coloured speed flashing across the picture. Fast roundabouts provide a challenge. How do you convey the spin, the excitment and the frenzied motion in a still picture. Try to use a shutter speed of, perhaps, $1/30$ second or less.

Don't miss your opportunity to go in close — catch the expressions on the faces of the bingo players — the satisfaction as a number comes up, the delight as a card is filled. This is where your long-focus lens will come in really useful. Go into the penny arcades, the homes of one-armed bandits, the glass-cased football and ice-hockey, and the pin tables — but take care. They often use fluorescent lighting.

Then, before you leave, why not go back to where you started — the ferris wheel, this time take a turn on it yourself, and when you get to the high spot of the ride, take a shot of the whole colourful arena spread out before you. But don't lean out too far!

Fireworks

One of the major events of the year, for children at any rate, is bonfire night, with its firework displays and Guy Fawkes burning merrily away on a hundred happy fires. In the past few years the small family and local group events have tended to disappear in favour of the bigger, more organised event. This is, to a great extent, in the favour of the photographer. Gone, admittedly, are the small fires with the children clustered around, faces bright and hands warm, but here to stay are the big bonfires, spectacular rocket displays and brilliantly-coloured set pieces.

For firework pictures, set your camera up on a tripod. Exposure is not too critical and suggestions are given in the table. Exciting pictures of rockets can be obtained if you make several exposures on the one frame of them shooting into the sky and bursting. If you can't override the double exposure prevention on your camera to do this, then set the shutter to 'B' and keep it open. Use a black card to cover the lens, moving it away only to record the fireworks actually going off. But be careful not to overdo it, three or four starbursts are quite enough on one frame. It isn't always possible to use a tripod because there are so many people milling about. If this is so, wait until the bigger displays start and you can fill your frame with fireworks, all burning at once. Try to include people in your pictures. Mostly they come out as black shadows against the flare of the roman candles and giant catherine wheels; but they still help to suggest excitement and atmosphere.

The bonfire, too, must be incuded, even if only for the record. There really should be people in the picture. If the fire is well fenced off, wait until the officials come and add more fuel. Most big shows are fenced off. If you are really keen to make a proper record and get some superb pictures, why not enquire before the night if you can go into the enclosure. You get an uninterrupted view, not only of the fireworks and the fire, but also of the spectators.

Lightning

At night, lightning is quite like fireworks to photograph. You have probably seen remarkable pictures with maybe three jagged bolts of

lightning forking their way across the night sky. They look good, don't they? Well, here is how to take them. Watch for a while to ascertain the direction of the storm, then simply set up your camera on a tripod, open the shutter – and wait for the flashes. You can't go wrong, it's so easy.

The best place to take pictures of lightning from is, of course, the safety of your own house. Open the window and shoot from there, try, if possible, to avoid street lighting, house lights, cars or any other source of illumination which will be overexposed on your picture. However, it does help if there are trees, or roof tops and chimneys around which will be faintly illuminated by the flashes.

Pictures by flash

When you want to illuminate night subjects, you can use your own portable lighting – flash. It is a very convenient way to take pictures. You don't need to consider the weather or the amount of light that is available, you just connect your flash unit to the camera, set the controls correctly and start taking pictures. All you need to worry about is your subject.

The simplest way is to mount the flash on your camera. This gives you bright, consistent, clean-cut results every time; barring, of course, the odd accident. However, flash on camera also has its disadvantages, not least of which is that, after a time, the same sort of subject illumination gets a bit boring and soon any challenge that there might have been rapidly disappears.

You can still get consistent high quality results with other flash techniques; and make your pictures a lot more exciting – both to take and to show. We will discuss some of them here in this section, but we will also look at ways of using flash on the camera to give you respectable results and pictures which are, perhaps, just a little bit different.

Flash on camera

The type of lighting you get from a single flash unit is harsh and contrasty. This is particularly so when your subject is near the camera.

155

As the subject is moved further away, the light reflected from the walls or ceilings helps to soften the contrast somewhat. However, when the light source is near the camera lens, the shadows cast are very small and the effect created is not unpleasant. Because the shadows are hardly seen, there is little *modelling* effect to show shape. Luckily, however, this seems to matter a lot less in colour work than it does in black and white. As you get further away from the background the lighting power of the flashgun falls off very rapidly. So, the further away from your subject the background is the darker it comes out. This can be helpful in creating separation between subject and background, but there is a sort of middle distance where a light-coloured background can look dirty and the subject's shadow big and ugly. So, you have the choice: put the subject quite close to the background or, alternatively, well forward from it.

Try to ensure that the background is reasonably tidy. Although the subject may be close to the camera and lighting power does fall off rapidly, it's amazing how objects which you hope won't show up usually do. Any shiny object in the background will always succeed in sending a dull, ugly reflection back to the camera. The moral is, be house proud.

There are two ways you can make your backgrounds acceptable. The first is by going in really close to your subject so that it fills the frame almost completely and there is very little background to be seen. This is sensible, because it concentrates interest on the subject. Alternatively, you can choose a plain, not-too-brilliantly coloured wall or, perhaps, curtain to set your subject in front of. Ideally, of course, it is best to do both.

Flash on camera is particularly convenient for spontaneous pictures; the children involved in a game of dressing up, waking up on Christmas morning to their presents, blowing out candles on a birthday cake – these are the moments when flash on camera comes into its own.

Don't run away with the idea that flash is only for pictures of children, though. Far from it. Use it to take pictures at your own parties and reunions with family and friends, at big events such as weddings, and christenings and simply to record the odd, informal picture of your husband or parents relaxing.

Problems

Apart from the lack of modelling, using a single flash unit on the camera creates a couple of special problems. Light is reflected back into the camera lens from any shiny surface. This happens with mirrors or windows, or even gloss paint. It also happens with spectacles and eyes. Unfortunately, if a spectacle wearer looks the camera in the eye, so to speak, the lenses of the spectacles simply show two unpleasant reflections of the flash. Your sitter's eyes are completely lost in the picture. Better results will be obtained if he simply turns his head slightly to one side. (Don't ask people who usually wear glasses to remove them. This usually produces a likeness which is less than good.) Reflections from the eyes themselves give rise to the red-eye problem which we mentioned earlier on. The nearer the flash unit is to the lens the more likely you are to get red eye. To avoid it, move the flash further away from the camera lens. Put a separate flash unit on a suitable bracket, or use a magicube extender if you have a magicube camera. If you can't move the flash , turn up the room lighting, or get your subjects to look away from the camera.

If you are taking pictures of groups, beware. Normally, when you set up a group picture, it is better to avoid having people standing or sitting in front of the camera in regimented rows. You get a more attractive result if you spread them out a little — some nearer the camera, some further away; some seated, some standing. When you use flash, it is not so easy to do this. By all means have some folks standing and some sitting but try to arrange things so that the farthest person from the camera is no more than a few feet back from the nearest person. This is because, as we said, the illumination from a small flashgun (in common with the illumination from any small lighting source) falls off very rapidly in power. A subject 8 feet away from the flashgun gets just one quarter of the light that falls on a subject 4 feet away. The reason for this is that the light from the flash doesn't travel forward in a narrow beam like the light from a spotlight — it spreads out both vertically and horizontally and, of course, loses intensity at the same time. If you want all the people in your picture to be well exposed, and to have clean, clear flesh tones, they make sure they are as near as possible to the correct distance from the flashgun.

Alternatives to flash on the camera

Flash off camera opens up tremendous possibilities for colour pictures. If you take your flashgun away from the camera, you open up a whole new world of opportunities. Unfortunately, this course isn't open to everybody. If your camera takes magicubes or flashbulbs, then you have little alternative but to leave the flash where it is – on top of the camera. You may be able to move it a few inches higher by using an extension unit. Special adapters are available to let you use electronic flash with magicube or flashcube cameras. These work well on most models, but because of the camera manufacturers' own specifications and tolerences, they may not work on all examples of any particular model. You just have to experiment with your camera to find out if you can use one.

An independent flash gun is a powerful, mobile light source. You can add light just as the mood takes you. In fact, you don't just have to have one flash unit – you can operate many at the same time.

Before we go into the possibilities of multiple flash, let's see what we can do with a simple flash unit merely by detaching it from the camera.

Bounced flash

One of the simplest ways to use flash off the camera indoors is to point it at the ceiling as you take the picture. The light from the gun is bounced back from the ceiling and reaches the subject as a soft, diffuse light. It is something akin to the illumination you get on a bright, cloudy day. Ideal lighting for pictures of people. It is completely free from the sharp, black shadows normally associated with flashlighting. It softens the features, so is particularly kind to middle-aged and elderly people. Of course, you don't have to bounce the flash from the ceiling. Bounce it from a wall, a large cardboard reflector or even a newspaper and you get soft directional illumination. However, do make sure that any surface you bounce from is white. Otherwise your illumination takes on the colour of the surface. Although walls can look very effective when they are coloured a delicate shade of green, human beings definitely do not. In point of fact, even though you may

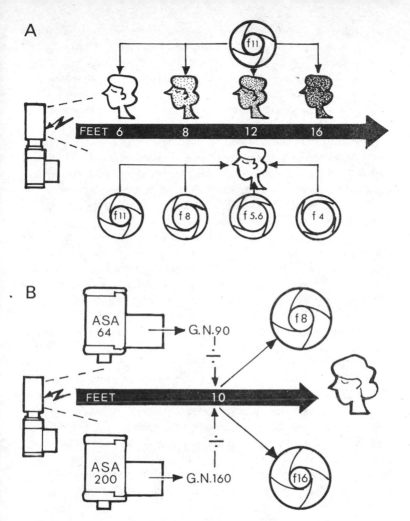

A. When you use a small light source (such as a flashgun), its illuminating power falls off very rapidly. Doubling the distance from light to subject gives not half the light, but only one quarter. In photographic terms, this means opening the lens aperture two stops, not one. B. Every flashgun (or bulb) has a guide number. Divide the guide number by the light-subject distance and you have the aperture you need to use—and vice-versa.

be bouncing light from a white ceiling, if the walls are strongly-coloured and fairly close to the subject, they can still cause a mild colour cast.

Some flash units have tilting mountings, so that you can leave them on the camera, yet bounce the light from any suitable surface. Computer units may even have an independent sensor, so that they give automatic exposure with bounced flash. With an ordinary flash-unit, bounced flash is easier if you have somebody with you to hold the gun. An extension flash lead to enable you to move about a little more freely helps, too. When you ask people to hold lights for you, always make sure they understand what they are doing. Explain where the light comes from, how it spreads out, and how important it is that the flash is held in just the right position.

Even when an assistant understands this, after a few minutes the arm becomes tired, interest wanes and the light starts to wander around a little. Particularly if the subject is an attractive girl who is much more interesting to look at than the flash unit. A better method is to fix the flashgun to a tripod — you know that won't lose interest!

When you use bounced flash, you can't calculate the exposure directly from the guide number. Obviously, you have to calculate the distance the flash has to travel before it reaches the subject — that is, the distance from the unit to the ceiling plus the distance from the ceiling to the subject — but, in addition, you have to take into account the light that is absorbed by the ceiling and also the light reflected away from the subject. Normally, given fairly average conditions, an extra stop should cover this. If for instance the distance from flashgun to subject (via the ceiling) is 10 feet and your guide number is 80, use $f5.6$ instead of $f8$. The best way to gain experience, of course, is by practice, but if the subject is important and the conditions unusual, then take several shots varying the exposure in each case.

Flash off the camera

There are two advantages to be gained from using direct flash off the camera. The first is, of course, that red-eye disappears, even if the flash unit is moved but a little further from the camera lens. The really big advantage, though, is that as the light source is moved further

away from the camera lens, the modelling of the subject is improved and its shape becomes much more obvious. Shadows begin to appear and, although they are fairly heavy ones, they do show how your subject is formed.

Supposing, for instance, you simply move the flashhead upwards, keeping it directly above the camera lens. Then, assuming that we are looking at a person's face, as the light starts to move upwards, the first noticeable shadows begin to form under the eyebrows, the nose and the chin, becoming more pronounced as the light continues to rise. Soon, the cheek hollows become darker and more pronounced, the shadow under the lower lip becomes more obvious and the eyes are completely lost in shade. If the lamp is now moved to one side or the other, the shadows are thrown diagonally and a rather more attractive form of lighting begins to emerge. All this is rather different from the flat, somewhat pudding-like effect you get with flash on your camera.

However, because the shadows are so black with no detail in them whatsoever, this lighting is still, to a great extent, unusable. To make it useful, it is necessary to cut down contrast by lighting up the shadows. It is possible to do this either by using a white, or silver, board reflector (which you can make yourself) or by using one or more extra flash units.

Multiple flash

If you are seriously interested in portraiture or indoor photography generally, using flash, then one of the best investments you can make is to buy one, or perhaps two, extra flash units. These units may be connected to the camera through a normal flash lead. For this, you need a Y-connector unless you use one gun on the hot shoe, and one on a long lead. Be careful when you fire more than one gun directly from the contacts on your camera. It is possible to overload the electrical contact. It is unwise even to plug two different models of gun into one sychronizing contact. If you use much accessory flash, you are better advised to use light-operated slave units. These may be built into slave guns, or purchased as separate accessories for use with ordinary flashguns.

Slave units are equipped with a photocell which is triggered off as soon as it "sees" the main flash. So you have to put them where they can pick up the light from the master unit. Camera exposure also has to be sufficiently long to allow for the delay between the main flash and the slave going off. Full instructions to account for any delay should be included with the units, but if for some reason they are not, use $\frac{1}{30}$ second or less (with focal-plane shutters $\frac{1}{15}$ second might be a better bet). Although slave units are most commonly built into or used with electronic flash, they are also available for bulb flashguns, or even for magicubes.

Slave units can be very sensitive, so don't be surprised if, by switching on a table lamp or a room light, you also fire the flashes. When you get more than one flashgun, think about having them all the same power. This makes exposure calculation easier. When you use multiple flash one flashgun can be much closer to the sitter than the others, to serve as the main directional key light. This gun is fired through a cord, and its light activates slave units. A second slave-operated gun might be used to light the background or, adapted for spotlighting hair and so on.

Calculating exposure when using several lamps is carried out in the normal way. Take the guide number for the main light and work your exposure out from that, disregarding the other flashguns entirely. The main light provides the basic source of light for the subject, while the others only fill in the shadows or provide background lighting.

Interiors

You can use multiple flash to photograph large rooms, perhaps in your own home, when you certainly couldn't light them successfully with one flash on the camera. Light each part of the subject separately with a single lamp. The lighting has to be even – you don't want one part more brightly lit than any other. So you have to make sure that each light is the correct distance from that part of the subject it is lighting.

Work it out like this. Put the first lamp into position and calculate from the guide number the exposure you need to use. Then, divide the aperture you have just worked out into the guide number for each unit.

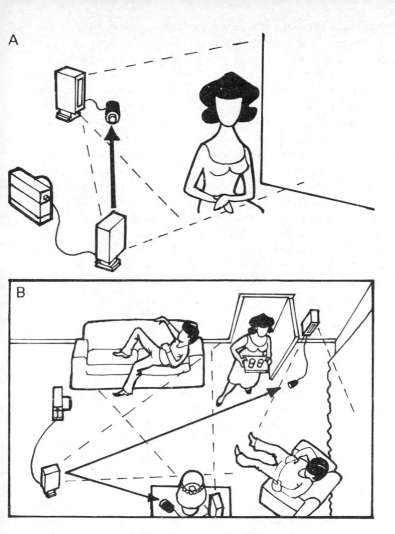

A. Use a second flash unit to provide fill-in lighting for a portrait. Keep it as close to the camera as possible, so that it doesn't throw secondary shadows, and make sure it is 1–2 stops less powerful than the main flash. You can use the light from your fill-in unit to give your main flash through a light-sensitive slave unit. B. You can use several slave units to ensure even lighting over a large area. Arrange them so that the light they throw will appear as natural as possible.

This gives you the distance each additional unit needs to be from the subject it is lighting. Try to make sure that the flashes don't overlap too much, otherwise your pictures will be patchy.

There are a few points worth bearing in mind when you are photographing a room set-up. You probably don't want the flash units in the picture. The obvious way round this difficulty is to position them behind suitable objects. However, you have to remember that in order to trigger itself, slave units have to "see" the flash from the master unit. Another problem is windows or other shiny surfaces. When you set up your lighting you may not notice these nuisances, but you certainly will when you get your pictures back from processing and see those terrible reflections. The best way to cope with this problem is to have somebody hold a lamp or torch in the position occupied by each flash gun while you watch from the camera position. If any reflections are likely to occur in your picture you will see them. One tip for making pictures like this look natural is to switch the room lights on and use a longish shutter speed — perhaps $1/15$ second — so that they burn in.

Paraflash

Professional photographers favour a form of bounced flash called paraflash or umbrella flash. A paraflash unit is a white umbrella which is attached (open) to a tripod or similar stand. The inside part of the brolly points to the subject. The flashgun, also attached to the stand, is directed up into it. When the flash is fired, most of the light is reflected back from the white umbrella on to the subject, giving a soft, gentle, yet still quite directional illumination. Units are also made with "silver" or "gold" linings. These give more directional light. The gold-tinted lining is popular with portrait photographers.

A useful feature of the paraflash unit is its portability; when not in use it simply folds up and can be carried, just like a conventional umbrella. It is an independent source of bounced flashlight — no more worries about coloured walls or ceiling, and no more worries about whether to open up one stop or two. Simply use the guide number for the flash and brolly unit to tell you exactly what exposure to give, or if none is given, carry out a few test exposures and find out exactly what increase you need to give.

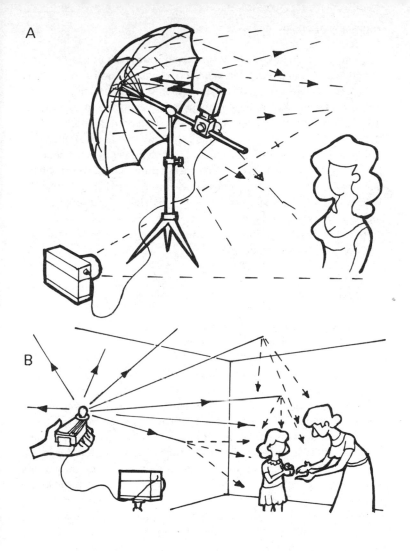

Two methods of achieving softly-lit portraits are as shown above. A. Paraflash—a white brolly—bounces the flashlight onto the subject. B. Flash without a reflector is usually only possible with bulb flash. The light is semi-directional, coming mainly from the unit, but is softened somewhat by the reflections from the walls and ceiling. It is not suitable for strongly-coloured rooms because colour-casts can occur.

Reflectorless flash

You can get illumination similar to that of paraflash but rather more directional by taking the reflector unit off a flashgun, and using the bare bulb. It is not always possible to do this with electronic flashguns and is impossible with flashcubes and magicubes. When you fire a bulb gun like this, the subject not only receives the strongly directional light from the bulb, it also has the benefit of the softening effect of the light which is reflected from the walls and ceiling. This gives a light, open shadow. Obviously, because you are not using a reflector to concentrate all the light on the subject, you have to use a rather wider aperture than the guide number would suggest. Try opening up by 1—2 stops when you are working in fairly small rooms or 2—3 stops in large or darker-coloured rooms. Be careful, too, if you are using flash on camera, that you don't get burned as the bulb fires.

Flash outdoors

Of course, you don't only have to use flash indoors, you can use it outside, too. There will be frequent occasions when you want to take pictures out of doors, but because the light is not bright enough, the film you are using is too slow or because you have a camera which only lets you operate in bright sunny conditions, you are prevented from doing so. But you can take pictures if you use flash. Not seascapes, of course, or whole buildings — you still have to remember your guide numbers and work out your exposures in the same way, which probably limits you to a maximum distance of about 20 feet from your subject — but you can certainly take pictures of people or objects which are reasonably close to the camera. Pictures at night can be especially striking. Your subject — in brilliant colour — stands out of the surrounding blackness. Try looking for subjects with a torch, many night creatures freeze in the light, giving time to take a picture.

Fill-in flash

Another reason for using flash out of doors is to balance strong sunlight. If you are taking a portrait, for instance, and the lighting is

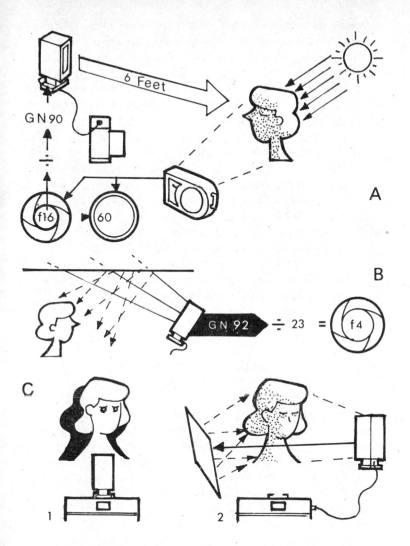

A. Use flash to soften harsh shadows in sunlight. Take a meter reading and divide the *f* no by the guide number to obtain the *closest* distance for the flash. B. A good rule of thumb when using bounced flash in a medium-sized room is to divide the guide number by 23 to obtain the aperture. C. For more interesting flash portraits, use flash off camera with a reflector (white, of course).

extremely contrasty — bright highlights and harsh, heavy shadows — use your flash to lighten the shadows and soften them a little.

Fill-in flash is slightly tricky, for if you use too much flash it will overpower the sunlight and become the main source of lighting, while the sun acts as the fill-in illumination. This is not what you want and looks very odd and unnatural. To provide a reasonably natural-looking effect, the flash should under-expose the subject by approximately two stops. For example, if your flash needs an aperture of f5.6 to give full exposure from the camera distance, you need an aperture of f11 for suitable fill-in. Calculate your correct daylight exposure, and alter the shutter speed so that you can get a properly exposed picture at f11. Remember however, you can only use fast shutter speeds with flashbulbs if your camera has M-synchronization. With a diaphragm shutter, you can use any shutter speed with electronic flash, but you *have* to use X-synchronisation; and with focal plane shutters you *cannot* use speeds faster than that recommended in the instruction book (1/30th for electronic flash if you are unsure). For faster speeds, you can only use focal plane bulb on F-synchronization.

Modelling lights

One problem with flash is that you can't see what sort of result you're going to get until the pictures return from processing. You can only guess with fill-in flash. A good idea is to buy yourself a couple of small reflectors which you can wire up and use as modelling lights with ordinary bulbs in them. These show you exactly what happens when you arrange your lighting. If you have only one flash unit, use only one lamp to guide you. If you have two flash units, use two lamps. Obviously, you will get a much truer impression of your lighting set-up if you turn off the general room lighting when using your guide lights. When you are satisfied with the lighting scheme you have devised, replace the guide lights with flash units.

Extension leads

An inexpensive accessory which you are almost certain to need as you start moving your flashgun around is an extension lead. This will

extend the short lead already fitted to the flashgun. With a bulb flash, make sure your batteries are in good condition, too — they need to be in order to overcome the extra resistance of the longer lead.

If your camera has only a "hot-shoe" contact, you can buy an adapter to take the extension lead.

Freezing motion

If you are using electronic flash on the camera, don't forget its ability to stop action. You can perform the old cowboy trick of flipping a coin in the air and shooting it before it hits the ground, if you want to (photographically, of course). Water is a fascinating subject for the electronic flash camera — if you doubt it, try photographing two infants splashing about in the bath and squeezing the water from their sponges. Often droplets will be caught in mid-air and the water generally will take on a solid frozen appearance with all the splashes caught and stopped.

Tungsten lighting

As we have said, one of the problems of using flash is that you are never really sure of the effect you are going to get until you see your pictures. By this time, it is usually too late to do anything about the ones which didn't quite come off. Just breathe a sigh of disappointment and hope for the best next time. A way around this difficulty is to use tungsten lighting, in spots or floodlight fittings.

Of course, you can't use this type of lighting in every situation where you would otherwise use flash. The bulbs need reflectors, stands, trailing wires and, last but not least, a main electricity supply. All this adds up to a distinct lack of portability. Where tungsten lighting really does come into its own is if it is used for taking portraits, still life subjects, table-top set-ups and, oddly enough, large rooms or areas which are difficult to light evenly or without the source of illumination appearing in the picture.

Photolamps

Photolamps, such as No. 1 Photofloods look just like ordinary 100 watt household bulbs. But they burn much more brightly and get very hot very quickly. They are, in fact, over-run; that is, they are constructed as if for a lower voltage. If you were to leave one switched on continuously, it would burn out after about two or three hours. No. 2 Photofloods are about the size of 150 watt bulbs. They give out about twice as much light as No 1 and can burn continuously for about eight hours. Obviously, photofloods are never left burning continuously for these long periods, and a careful worker (who wants to be really cool) switches off during the periods of setting up and changing poses.

A convenient method of working is to wire up pairs of bulbs so that they can be switched from series to parallel. In other words, the electricity goes either through both bulbs in turn, or through each separately. This means that you get dull light and long life for setting up. You switch to series operation for full power just before taking the picture.

To get the maximum benefit from photolamps you need to fit them into reflectors and preferably fix them on lighting stands so that you can place them at exactly the right height and in the correct position. There are a variety of sizes and shapes of reflectors on the market, ranging from big, shallow bowls (which give a soft flood of light which is only slightly directional) to small, deep bowls (which give a more concentrated beam). Photo-lamps are also available with their own built-in reflector, which is rather convenient, but restricts you to a fixed type of beam.

Photolamps, such as Photofloods, must be used with type A film; or a suitable correction filter must be placed over the lens.

Studio lamps

Instead of photolamps, you can use high-powered studio tungsten lamps. Although these lamps are not as powerful as Photofloods, they last a good deal longer because they are not over-run. The light they produce is somewhat more yellow-red than photolamp lighting. So they need to be used in conjuction with yet another type of film — type B or a suitable conversion filter.

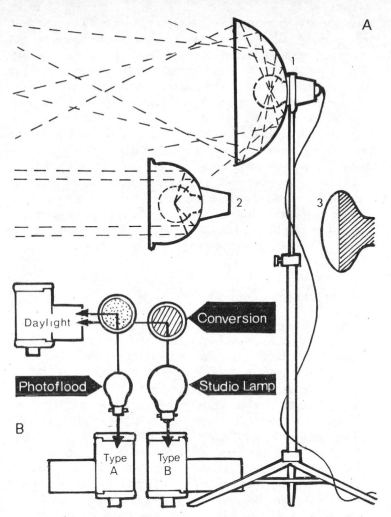

A. Reflector shape controls the light from incandescent bulbs. (1) Large, shallow, dish-type reflectors give soft, rather flat lighting. (2) Deep, bowl-type reflectors give a much more concentrated, directional light. (3) Internally-silvered lamps contain their own built-in reflector. They give a hard, concentrated light. B. Using light sources for which the film is not balanced will cause a strong colour cast in your pictures. If possible use the right film, otherwise you will need a suitable conversion filter.

Although the idea of using different types of film or filters may strike you as adding unwanted complications to your photography, this won't really happen. First of all, you will probably decide to standardize on one type of illumination – either Photolamp or studio lamp so you can forget completely the existence of the other type. You will then only have to consider buying daylight type film – for your daylight and flash pictures – or suitable artificial light type – to suit your indoor lighting. If you really want to, you can simplify matters even further by sticking only to daylight type film and using the necessary conversion filter when you want to use your studio lighting. This is not, however, really recommended, though, for you lose valuable film speed due to the filter.

Always remember to exclude all daylight when you are using artificial lighting. You may not notice it at the time, but it shows up in your pictures as a most unpleasant blue cast wherever it falls.

Portrait lighting

If you plan to take up portrait photography of the more conventional type, where the subject is specially posed, dressed and groomed for the occasion, you need three lamps and reflector units. Fewer lamps means that you are restricting yourself unnecessarily – you can manage with two for a while, but sooner rather than later you will need the third! More than three lamps, for the beginner at least, leads to unwanted complications. You also need a largish room, and a plain background – perhaps a softly coloured wall or curtain.

To set up a portrait, place your model as far forward from the background as you can, remembering that you will also need room to position the camera and lights. This ensures that any pattern on the background will be well out of focus and that shadows will generally fall ouside the picture area. If you can, fit a longer-than-normal focal length lens to your camera. Set up the camera to give you the picture you want. Going closer than about three feet (which you may have to with a standard lens) leads to some distortion of the features: your subjects apparently gain long noses and lose their chins and foreheads. This is less obvious with babies and young children who have rather flattened features.

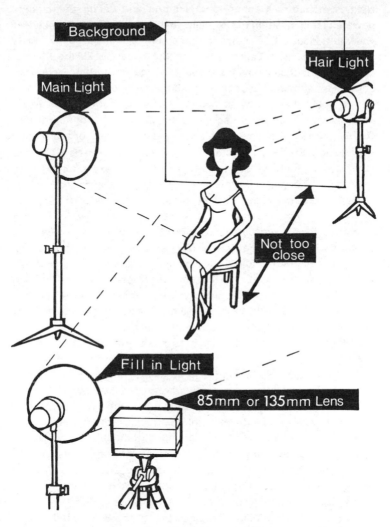

A good, simple yet well-balanced portrait lighting set-up. The main (key) light provides modelling, the fill-in light softens the harsh black shadows and the hair light adds sparkle and a slight halo effect. Don't let the colours of clothing or background dominate the picture but try to make sure they suit the personality of the sitter. If you have one, use a long focus lens, so that you can keep well back and still fill the frame.

Next, switch off all other room lighting and, using the highest powered lamp, position the key light so that it gives exactly the effect you want. Place a fill-in close to the camera and on the same side as the main light. Put it at such a distance that it does not kill the effect of the main light or cast obvious shadows of its own. To achieve a good balance of light and shade in the photograph, your lighting needs to be just about one quarter as contrasty as looks right to the eye, so make sure your shadow areas are not too black. With your third light, you can either illuminate the background or the hair of the model, depending on the effect you are trying to create. On page 173 there is a typical lighting set-up which you can experiment with. Remember, though, this is an example of a basic arrangement. For really exciting results you need to suit lighting to subject – and this is *your* job.

You will find that a most attractive type of portrait lighting is found out of doors when the sun can just be distinguished through hazy clouds. The light is then soft and slightly directional. Indoors you can achieve the same effect with big, shallow bowl reflectors to bounce the light from high up on a plain-coloured wall. Any fill-in light necessary can then be bounced directly from the ceiling. One again, be sure that light only bounces from really white surfaces. Even a small green cushion can reflect enough discoloured light to make your subject look rather greasy.

The disadvantage of concentrating on daylight portraits is that you must wait for exactly the right conditions. In particular, even when the sun is just nicely diffused, it may be coming from the wrong angle. This can force you to include an unpleasant background. One of the pleasures of working with flood lighting is that you can see exactly what you are doing and you can keep moving the lamps until you find just the effect you need. However, to achieve anything, you *must* experiment using the main light only. Always switch the other lights off when you are altering the position of the main light so that you can see exactly what you are doing. If, when all the lights are switched on, you find that the effect is not what you wanted to achieve, don't try to change it by altering the fill-in light or by bringing in another light. This way you will land up in a hopeless mess, not knowing which lamp is throwing which shadow or which highlight. When you get problems, always start by switching off all lights exept the main one. Then if that *is*

the cause of your problem, move it. The fill-in light should normally never give you problems because it is intended basically as a flat, overall lighting which gives no shadows of any consequence.

A few points

There are some do's and don'ts which are fairly easily remembered and which will help you to make good portraits. They are not to be taken as rules but rather as guidelines good for the majority of cases but not necessarily for all.

Try to avoid seating your model with shoulders square on to the camera. A much better, less bulky, effect can be obtained by having the sitter turn the body slightly away, then, if you want a full face portrait, turning the face only to the camera.

Never force the sitter into a pose that doesn't come naturally. It is bound to look awkward in the picture.

Never light your subject in such a way that more than one shadow is cast by any facial feature. If more than one shadow is cast it means your fill-in light is too strong.

Unless you are trying to achieve a special, slightly eerie effect, never position the main light lower than the sitter's face.

Avoid brilliantly coloured backgrounds unless you have a special effect in mind. If possible, use quiet, receding colours such as pastel blues, creams, browns and greens. You can alter the brightness of the background by altering the amount of light you throw on it.

Unless clothing is a feature of the picture, keep colours and patterns of clothes simple and unobtrusive. The sitter's face is the important feature, not the orange tie or pink ribbon they happen to be wearing.

Most people have a good side and not-so-good side to their face. The better side is usually rather broader. Without staring too much and making them uncomfortable, try to detect the better side of the sitter's face and feature that.

Portrait techniques

A few last words to help you on your way to taking good portraits. First, try to have everything set up before your sitter arrives. Nothing is more boring for a model than to have to wait while the photographer tries to find this and hunts for that. All you should have to do is sit him or her down and then arrange the lighting as you think best. Besides, you need all the time you have with your model for taking pictures. If you can, try to chat casually with the person you are photographing. Most people are nervous when they have their pictures taken and light conversation can help put them at their ease. Make a point of finding out what interests *them* and talk about that, rather than what interests you. Finally, people are usually most nervous and tense at the start of a picture-taking session. As time wears on and more pictures are taken, they begin to unwind and realise it isn't as bad as they thought. It is from this moment on that you start to get the good pictures. Instead of wasting pictures early on, therefore, try pretending that you are taking pictures. After a half-dozen or so pseudo-exposures the sitter has usually loosened up and you can get down to some serious work.

With flood lighting you can also take pictures of people in their own natural surroundings. Dad relaxing in his favourite armchair, your wife putting a record on the turntable – these can all be captured with photoflood lighting almost as easily as with flash or available light. What you must strive for though, is the simplest possible lighting – fairly soft with no shadows. The effect you need is a natural, homely one. The easiest way to achieve this is by bouncing the lighting – the main light from high off a wall and part of the ceiling, the fill-in from the ceiling only. A good way to soften heavy shadows under the chin, or on an unlit side of the face, is to have your subject reading a newspaper, or positioned near a white or light grey surface which will act as a reflector.

Still life

Another type of photography which is most easily tackled with flood lighting is still-life photography. As the name suggests, still-life is pic-

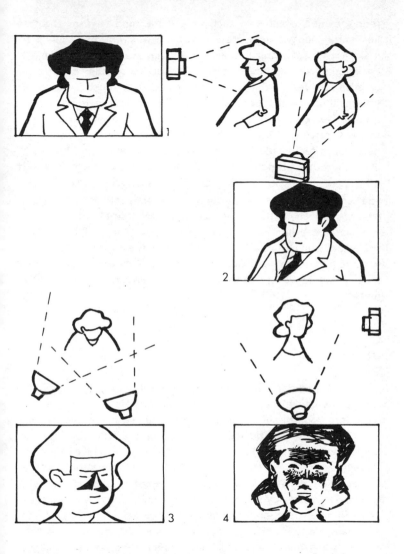

Some of the don'ts for portraiture: (1) Don't have the subject square on to the camera. A three-quarter position with face turned to the camera is more flattering. (2) Don't have two main lights. The result is double shadows and an ugly effect. (3) Don't have the main light *lower* than the face unless you want a rather weird result.

turing inanimate subjects such as a flower and a vase. The test lies in arranging your subjects to make it look as simple as it sounds. To make a really satisfying composition you have to choose the subject, background and lighting with great care. There has to be some creative idea behind the picture; you can't simply push a cut flower into the first vase that comes to hand. The picture has to be built up from an idea in your mind to its arrangement on the set. Colours have to harmonize; you wouldn't set a yellow rose against an orange background for instance. Lighting has to have a purpose. It may be to show the subject simply and clearly as it is, or it may be to create an effect—perhaps of early morning, or light streaming through a window.

The best type of lights for this sort of work are spotlights. They give a lot more "punch" to the picture and they are extremely controllable — you can adjust them so that they give a large pool of light or a tiny spot of brilliance. However, spotlights are fairly expensive and, unless you need to produce specially dramatic and unusual effects, you can probably get by using one spot and a fill-in lamp in an ordinary bowl reflector.

Glassware

Glassware can produce fascinating pictures but is difficult to illuminate well unless you know the secret. Have a look in the glassware department of the next large store you visit and you will see how it's done. The idea is to place the article you want to photograph on an opal glass, or plastic shelf with a sheet of the same material behind it. Put one lamp low down, behind the subject so that the glass is backlit. You can achieve many beautiful effects with glassware, merely by pouring coloured liquids into the container — golden ambers, rich maroons and wines, blues and greens all give extremely pretty effects. Try, too, using coloured filters over the light source and instead of plain opal screens try using textured glass to give a patterned effect behind the subject. Taking still-life or table-top pictures, you need to go in close. If your camera won't focus down to about 18 inches or 2 feet, then you will need a close-up lens. You can buy these fairly cheaply to fit most cameras.

"Glass top" photography uses several layers of glass and cut-out shapes. (1) Foreground (2) Middle distance (3) Distance (4) Far distance and sky. Try experimenting with coloured filters over the lights and see what effects you can create.

Table-top photography

Unlike still-life, table-top photography involves building a scene in miniature, on a table-top, using models, toys, miniature ornaments and such. The idea is not necessarily to create a realistic effect (this rarely works anyway) but to build up a little fantasy world. For instance you might build up a winter scene in the following way: use salt, sugar or even cotton wool to simulate snow and a small mirror to act as a frozen lake; make a woodland area from privet twigs stripped of leaves; use black card riddled with pinholes and backlit to act as a starlit sky; finally add a few china or glass figures as skaters and you have a wintry scene straight from the world of fairy tales. A spotlight is best as a main light and very soft fill-in can be provided by a low-power flood.

One of the main disadvantages of table-top photography using a table top is that you nearly always have to take your pictures from slightly above, looking down at an angle. Glass-top photography is one way round this problem: instead of building a three-dimensional set on a table you use a series of cut-outs or objects on glass. Construct a unit similar to a low, glass-topped coffee table, but instead of just one surface of glass you have three or four, one above the other. To create the set, make your background out of paper cut-outs (or whatever fills the bill) and place this on the bottom shelf, build the middle distance on the middle shelf and the foreground on the top shelf. You then take your picture from vertically above, looking down.

A great advantage of any still-life model or table-top photography is that you can decide the exact colour composition you want. You can restrict yourself to a single colour, or choose a whole range of glowing hues. All making a coherent whole, of course.

Something
out of the
Ordinary

Taking colour pictures is exciting, it's fun and it's a challenge. You can never reach the stage where you can say "Right, I've covered that subject completely. I know all there is to know about it. Where do I go from here?" The moment you say that is the moment you die photographically, for there is always something new to learn, a different way to tackle a subject, a new thrill as you achieve a desired result.

This chapter is all about different ways to tackle perhaps rather ordinary subjects. In the process of doing so, there might just be something to learn and perhaps a little excitement when you find your pictures have taken on an unusual twist. However, the methods outlined are only starting points. Photography is, more than anything else, a creative medium and as you learn the basic techniques it is up to you to develop them, apply them to different types of subject. Pictures are the result of *your* looking at a subject and deciding *you* want to record it.

You don't have to record it as it stands, though, baldly and unimaginatively. Think about it and think around it. What appeals to you most about the subject? Is it colour? Then, take the dominant colour and echo it through the picture. Is it restfulness? Then make a feature of the quiet, peacefulness of the scene. Whatever it is, portray it. The way you do so is up to you. Use thought and imagination. Occasionally you will end up with some pretty terrible slides or prints; but for every ten failures you have, you'll get at least one success to make it all worthwhile.

Anyway, every failure you produce teaches you something – even if it is only not to try that effect again. Don't be put off if your friends don't particularly like your results, either. The important thing is whether *you* like them. If you can honestly say you do, then you have succeeded. A consoling thought perhaps, is that few great artists are recognized until after their deaths.

A different way of seeing

Normally you see things from pretty standardized viewpoints. You and I take most everyday scenes for granted. If we see something which looks interesting, we may stop for a second look, perhaps even decide to photograph it.

How often, though, do you go really close to the subject and examine it minutely from every possible viewpoint? Not often — there just wouldn't be enough time and, perhaps it wouldn't be worthwhile for all subjects. Every once in a while, though, you can come across what seems like an ordinary subject, but somehow, something about it catches your imagination. You look at it from all angles and, suddenly, you see it not as it really is — a backlit picket fence or a mass of telegraph wires converging in a single point — but as a pattern of light and shade, colour patches or lines.

Photograph it just as you see it. The subject may be unrecognisable to anyone else who sees the picture. That is immaterial. As a *picture* the photograph stands on its own. It is a design rather than a photograph, a pattern of shapes used by you to create something which is more than just a mere record of the subject in question.

You can develop the ability to look at things in a different way. Take a subject which interests you — it could be a new, excitingly-designed shopping precinct, with high-level walkways and escalators; it could be an old, disused railway station with boarded-up windows and rusting, weed-covered rails; it could even be your local woods. Go out, with your camera, and with any lenses — wide-angle, telephoto or close-up that you have and with any filters, spend an afternoon just looking through the viewfinder to see how many ways you can find of interpreting that subject.

Suppose you select the shopping precinct, then these are the sort of pictures you might see. First of all, the reflections in the shop windows. The images reflected in the glass combined with the actual wares in the window can make up some spectacular colour effects. Look up and see the patterns and angles created between the walkways on the different levels and the escalators. Stand so that you look between them, to get an angular, multi-sided frame to your picture.

Go to the top level and look down, vertically, so that the walls of the building drop sheer away from you. Looking up or down vertically often produces interesting pictures — unusual too, because very few people ever do view things that way. Most people look at a tall building from some distance away so that they can take it all in without craning their necks. They choose what you could call a "normal" viewpoint. You don't want pictures taken only from a "normal"

viewpoint, though. You want pictures which are different as well.

How do you assess exposure for shots which are different? That's what you call an impossible question, for you can't generalise with this type of photography – no two subjects are ever really alike. Again, it's a matter of exposing for what you want to show. Frequently, special effects pictures have strong contrasts. Contrasts with which no film could ever cope. Ask yourself, then, do you want detail in the deep shadows or in the brilliant highlights? Make your exposure work to help you. Will your picture look more dramatic for having strong, black shadows created by exposing for the highlights, or would you prefer to see not only detail in the shadows, but light from the sky flaring and spilling over the dark edges from overexposure? Bracketing exposures is a good idea when you photograph subjects like this – one shot at the exposure indicated by the meter, one at a stop under and one at a stop over. Remember, you are after something different. Don't be afraid to go for it.

Mood pictures

Pictures may be taken to put over a mood or feeling. Peace, tranquility, drama, loneliness, power – these are all impressions, or feelings – and there are many more – which we can attempt to convey in our pictures. Mood pictures generally occur spontaneously – the sun comes out after a rainstorm, the grass takes on a particularly emerald sparkle and suddenly there is a rainbow. The quality is almost dreamlike or ethereal. How do you catch a picture like this? Simple. Merely by having your camera with you, being ready to shoot and actually realizing that you have before you a potential picture. Many photographers put their cameras away when it rains or when the light becomes dim. This is when the photographer of moods gets his camera ready for action. Incidentally, this is a good time to answer a question we asked earlier on in this book, "how do you capture a rainbow?". Well, it's not difficult. In fact, a perfectly normal exposure will do the job. However, to achieve maximum colour and brilliance in that beautiful arc, try under-exposing slightly, perhaps by half to one stop. Backlighting can produce some wonderful mood shots, and generally add a feeling of warmth or freshness to a picture. However, it can also

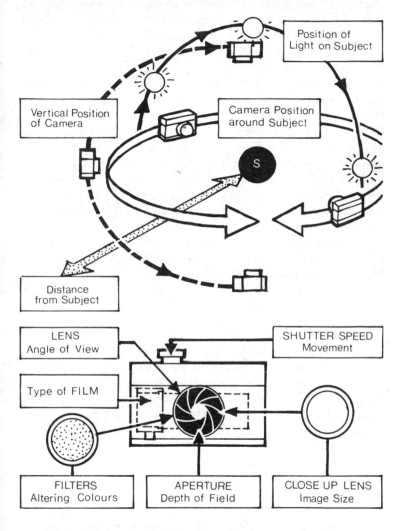

If you want to make really good colour pictures, think carefully each time you release the shutter. Move around your subject, and think how changing the lighting could improve your picture. Don't forget the camera's features that you may be able to use to get just the result you want.

produce an impression of power or strength. Next time you are looking at some old ruins – perhaps an ancient abbey or an old tin mine in Cornwall – look up from the shadow side of it. Try looking through a window, using the crossbar of the window to just shield the sun from your eyes. The window is in silhouette, but the sun flashes around the edges of the brickwork creating a brilliant and dramatic effect. Choose the most dramatic viewpoint for your picture. Slight under-exposure can add to the colours and dramatize the effect.

Of course, you don't have to wait until mood pictures come along. You can go out and find them. Early morning, from just about dawn onwards, is the best time of day and autumn is probably the best season. This is when you will find the mists rising and the sunbeams filtering through the haze. When the spiders' webs hang from the branches of the trees, and jewel-like droplets of water are suspended, reflecting the colours of the spectrum.

These are the times when even the most modern of housing estates can look a haven of restfulness, and the moorland village a positive fairyland. If you take transparencies, load up with a fairly fast film – around 160 ASA – this helps two ways. It gives you enough speed to cope with the poor lighting, and has fairly low contrast to emphasise the soft conditions. Make maximum use of wide apertures, when exposing, to throw foreground and background out of focus. But make your main subject sharp and clear. Try making a frame for your picture – some leaves, grasses or flowers perhaps. Go in really close to it so that it becomes just a soft, pastel-coloured haze – like a cloud, almost, around the subject. This effect is easiest to achieve with long focus lenses because they have little depth of field; but it is quite possible with a standard lens.

A lazy shutter

Earlier on in this book (on page 127 to be precise) we talked about showing movement in our picture. We also talked about using a medium-slow shutter speed and panning so that our subject would be sharp and the background a blur – thus we would gain the impression of speed and movement. We also suggested that keeping the camera still would make the moving part blurred.

Although we suggested that this is not a particularly satisfactory way to record moving subjects, it is a superb tool for the creative photographer.

You can try this technique any time there is movement in your subject. If you are at the seaside, and there are scores of gulls wheeling and diving, instead of using a shutter speed of, perhaps 1/500 second to catch them all fairly sharply, try instead 1/60 second or, perhaps, even 1/30 second. Some will be nothing more than nebulous white whisps against the sky, some will be captured quite crisply at they hover in the air, others will have their bodies clearly rendered but their wings will be soft, white veils. Try this close up, as one bird hovers to take a crust from somebody's hand.

Try a picture of a cornfield, or a group of trees standing on an isolated moorland where the wind is blowing strongly. Use an exposure time of about 1/15 second and close down your aperture to compensate. You may have to use really slow colour films to allow you to give long exposure times without over-exposing, but, in terms of colour quality, that is not a bad thing. Always have your camera firmly mounted, preferably on a tripod too, because you want everything in your picture which is not moving to be really crisp.

Sports meetings, of course, give you the ideal opportunity to create weird and wonderful effects using a "lazy shutter". Photograph a runner, again using an exposure time of 1/15 − 1/30 second and either keeping the camera as still as possible or, perhaps, panning it *slowly*. Arms and legs will be a blur of nebulous motion while head and body will be not *too* badly defined. As well as across-the-camera motion here, you will also have some up-and-down movement from the limbs.

Some of the effects you can achieve using slow shutter speeds can be very strange. Colours merge into one another as though they were liquid; limbs and faces become distorted by movement. Certainly, not every picture you take will be successful, but it is worth experimenting. Success rate could be about 50 per cent, or more when you become practised.

While we're on the subject of slow shutter speeds, don't imagine that the only movement should come from the subjects in your picture. You may have a scene in front of you in which everything is static − no life at all. Take a second shot after you have made your record, but this

time use a slow shutter speed and move the camera slightly sideways. This can produce fascinating results, particularly when the subject comprises a number of straight vertical lines. In the moved picture, there will probably be a rather strong main image with a less strong secondary image beside it, the two images joined by a light streaking. Try moving the camera around during a really long night exposure. Points of light trace lines on the film, and maybe you can add something special to an otherwise rather plain scene.

Multiple exposures

If your camera allows, you can make double exposures to show stages of movement. For two exposures put your camera on a tripod and set the controls so that you only give *half* the normal exposure. For example, should the meter tell you to give $1/60$ second at $f11$, then you can either give $1/125$ second $f11$ or $1/60$ second at $f16$. Whether you alter the aperture or the shutter speed depends on the normal movement and depth-of-field criteria. Take the first picture, don't wind on, then take the second. If the subject is static, perhaps you can move the camera sideways slightly or, up or down if you like between exposures. The result will be a perfectly clear, sharp picture, which overall is correctly exposed, but which shows a double image. Move the camera *sideways* when the subject is predominantly vertical – tall slender trees or upright fencing; move it up or down when horizontals dominate – ranch fencing or stacks of timber or piping.

You can also make double exposures of *different* subjects. Supposing you take an evening photograph which shows a blank sky. Before you wind on, try taking a picture of the moon – fitting the image into a suitable part of the "sky" area. If you do this at night, when the moon is fairly high, everything else will be in darkness and will not record over the image which is already there: If you are careful, the effect can be spectacular.

Filters for effects

Although you are taking pictures in colour, the colours in your photograph don't necessarily *have* to be genuine or correct. Certainly

they don't when you are striving for a special effect. If you previously took pictures in black and white, you probably have a small collection of colour filters, perhaps yellow or orange, red and green, which are now sitting doing nothing. Why not put them to work, producing exciting colour pictures.

For instance, you could be by the seaside taking a picture against the sun. Why not try taking the same picture using an orange filter so that you give an unusual appearance to the shot? Perhaps you could try a picture of the local high street through a light-red filter. Whatever you try, you can see what sort of a picture you are likely to get simply by looking through the filter beforehand. Don't forget, though, you need to increase the exposure when you put a filter in front of the lens.

Most filters have what is called a "filter factor" — the amount by which you need to increase the exposure. A $\times 2$ filter calls for double the exposure you would give if you were working without a filter; a $\times 4$ filter would need 4 times the exposure — that is, instead of, say, $1/100$ second at $f16$, you would need to give $1/100$ second at $f8$. A through-the-lens meter, of course, will take care of this automatically. If you don't have through-the-lens metering, you will have to work it out the hard way.

Have you ever wanted to take pictures at night, by moonlight? You can of course, but it calls for rather a long exposure. An alternative method is to choose a bright, sunny day, place a medium-blue filter in front of the lens — and under-expose. If you ignore the filter factor and give the exposure recommended by the meter (without the filter), you should get a convincing result.

Gelatin filters

Should you wish to try these techniques and as yet don't possess any filters, you can save yourself some money by buying gelatin instead of glass ones. Many colour filters are available as small rectangles of gelatin. They need to be handled very carefully, of course, by the extreme edges, for once you get a fingermark on gelatin, it is impossible to get it off. Provided you are careful, though, and keep them in their wrappings when not in use, gelatin filters offer very good value for money.

Special effects screens

If you would like to create some really pretty effects, then you might like to invest in a star filter or, perhaps, a transmission diffraction grating (which is not nearly so formidable as it sounds).

A star filter is not really a filter at all. It is simply an optically-flat piece of glass which fits your camera just like a conventional filter. It is inscribed with a cross pattern, or perhaps a series of spokes. When you place it over the lens it makes all point sources of light (including reflections) take on the shape of a star. The number of points in the star depends on the number of directions the lines are engraved on the filter. You often see star filters used to good effect on television, or in magazine advertisements. Another type of star filter has a grid pattern of criss-crossed lines on it. These filters give smaller, softer, more tapering rays to the star.

A transmission diffraction grating over the lens gives a different effect. Like the star filter, this is an optically-flat piece of clear glass but this time etched with thousands of precisely-shaped ridges. When you use a grating over the lens, it will still give a diffuse starburst effect, although not so precisely as a star filter. Its main result, however is a long beam, emanating from the point-source. The beam is broken up into a colour spectrum. The effect is that of a rainbow-coloured pencil of light beaming out above and below, or to both sides of the light-source.

Diffraction gratings and star filters require no increase in exposure, and you can see by looking through them what sort of effect you are going to get. You can rotate them so that you achieve exactly the effect you want and you can combine them with each other, or with other filters, to produce different results. Both diffraction gratings and star filters can be bought quite cheaply at most camera accessory shops. More detailed information on filters and screens is given in the Photoguide to Filters.

Unusual films

Because most unusual colour films are made for scientific purposes, they are available only in 35 mm. This is severely restricting unless

you use a 35 mm camera. But if you do, and don't mind expecting the unexpected, so to speak, experimenting with special films can be fun, and can give you some exciting pictures.

False-colour Infra-red film

Infra-red colour film such as Kodak Ektachrome Infra-red Film gives the strangest results. Unlike normal colour films, which are sensitive to blue, green and red light, infra-red colour film responds to green, red and infra-red radiation. As all the colour-producing layers are also sensitive to blue light, you should exclude this from the camera. Fit a strong yellow filter over the camera lens; preferably one which transmits no blue light at all. A typical example is a Kodak Wratten Filter No. 12. This filter is recommended at all times (whether daylight or artificial light) with false-colour infra-red film.

What sort of results are you going to get? That's a tricky one for, really there is simply no way of telling. You can't see infra-red radiation, so you do not know how much is being reflected from the objects in front of you. To give you a rough guide, however, blue skies become brilliant cyan (blue-green). Leaves and foliage appear red to purple, depending on how healthy they are. Skin tones can turn a striking green and veins show up below the skin. Red flowers may turn bright yellow. From there on, it all depends on the subject in front of you. Very few colours, if any, will record in the picture as they actually appeared to the naked eye, so whatever the subject you take, you are in for some surprises.

Incidentally, focusing can be a little tricky when you use this material. Infra-red radiation does not come to a focus at the same point as ordinary light, but the film you use will record both light and infra-red. The thing to do, therefore, is focus on the very front of the main subject and stop down as much as possible to get maximum depth of field. It is possible that the focusing scale on your camera may be marked for infra-red. If it is, ignore the mark as it shows the focus for infra-red alone, not for the light which also affects the film.

Infra-red materials are not always given an ASA speed so, before you do any serious work, you will have to make some tests. Using the yellow filter over the lens, try rating the material at 100 ASA, bracketing your exposures by ½ stop and 1 whole stop either way.

Thus, if for a film speed of 100 ASA your meter tells you an exposure of $1/125$ at f11 is called for, then, make five exposures altogether – one at the recommended setting, one halfway between f11 and f8, one at f8, one halfway between f11 and f16 and one at f16. Look at the processed results, and you can allocate your own ASA speed to the film you use.

If you would like to use a material which offers unusual colour effects but which does not require quite the same effort as infra-red film, then why not try Kodak Photomicrography Color Film 2483. This material is extremely contrasty and produces strongly saturated colours. Although slower than conventional colour films (ASA 16), it requires no special filters or working techniques and produces results which can only be described as different. Skin tones become a bright magenta, grass becomes a rich emerald green and yellow becomes quite violent.

Existing effects

Reflections are a good example of unusual existing effects. At night, for instance, after it has been raining, city streets reflect the neon signs, the shop window illuminations and the lights of passing cars in a beautiful shimmery way. Take a picture of just the reflections to produce a pure pattern in colour which seems divorced from reality. In daylight too pools and puddles of water can give you unusual pictures. Take a picture, directly, of the reflection (remembering to focus as far behind the surface of the water as the actual object is away from it), then, drop a pebble in the water and, before the ripples die away, take another picture.

Of course, water isn't the only thing which will give you interesting reflections. Look for pictures which are different in the backs of vehicle spotlamps or in hubcaps, and in the big bulbous headlamps on vintage cars – even the knobs on brass bedsteads can be called into service if you don't mind the overall colour cast. The trouble is you often end up having to include the reflection of yourself with the camera in this sort of shot. How do you fancy disguising yourself as a tree?

Try looking *through* things to achieve special effects. Some cafés and public houses have old-fashioned, bulls-eye windows which produce

attractive pictures when you photograph through them. If you can't find any of these, don't despair. Try using the base of an old jam jar or a coloured glass bottle (but remember to increase your exposure if you use coloured glass, for it will absorb light just like a colour filter). Of course, these techniques are suggestions — guidelines as to which direction you might head. You are really limited only by your imagination and initiative, for some of the ideas we have just discussed can be used as easily with a simple 126 camera as with the most expensive SLR. If you like the idea of producing pictures which are different, then always be on the lookout for ways of achieving effects and, no matter how outrageous your ideas seem, don't hesitate to put them into practice. Usually, the most you have to lose is a couple of frames of film.

Showing off – Just a Little

Photography has its problems. Not the least of these is what do you do with the pictures you collect. If you are like most other photographers, the moment you get your pictures back from processing is one of unconcealed delight. You tremble your way through the slides or prints you have taken, hardly stopping to admire the best, impatiently discarding the worst. Later, when you have more time to relax you examine them more closely, analysing them, gaining satisfaction from the good ones and disappointment from the not-so-good.

It's after this, however, that the real problem crops up. Just what do you do with your pictures? After you have spent so much time and energy producing what we hope are good photographs, it's a shame to just put them away in a drawer and forget about them. If they are good (and there's no reason why they shouldn't be) they deserve a wider audience, perhaps, than your immediate family. Maybe you would like to see them yourself a little more often, but it is such a job finding them and loading transparencies into the projector. Prints are a nuisance when you have to sort through packets and then the pictures themselves are a bit disappointing, simply because they are not well presented. Is there an answer? Well, yes, there is. There are several, in fact. Let's look at them a little more closely.

Editing and filing

Whether you take slides or prints, there are two things you will want to ensure: that your negatives or slides are kept as clean and as safe from damage as is humanly possible and that you can identify and find any one particular one at a moment's notice. It's common sense, really, to have some system of keeping your pictures safe, clean and instantly available.

Pictures can become more and more valuable as the years go on, and nothing is more dangerous to your precious originals than carelessness. A colour film emulsion is a delicate substance and is easily damaged. Once dust becomes ingrained in it, or it becomes scratched or fingermarked, it is spoiled forever. There is no easy, sure or safe way of cleaning a badly soiled negative or transparency, so treat yours carefully and with the respect they deserve. After all, you took them.

Editing is a movie-makers term, really, but it describes well the first job that has to be done. Sometime, after you have looked at them on several occasions, discard the prints or transparencies which do not come up to scratch. This is an extremely difficult thing to do, make no mistake. No photographer likes throwing out pictures which he has taken (although he is often willing to advise others with a similar problem), but it is a job which must be done purely to make life easier when your collection gets bigger.

So, one evening, when you feel strong, gather all your pictures before you and weed out the really poor ones – the ones you wouldn't willingly show to anybody. Discard the wildly over-exposed and the ridiculously under-exposed, the out-of-focus and the badly moved, the flared and the doubly-exposed. Discard, too, any others which, for whatever reason, you know you don't want. When this is done you are in a better position to organize the good pictures you have left. Just one point, though. If you have any transparencies which are completely black – no image on them at all – keep them. They can come in useful, as we shall explain later.

The next thing you need to do is arrange some way of keeping your slides, or your prints and negatives, together so that you can pick out any individual one that you want almost without hesitation. There are several methods of doing this with slides. The cheapest is simply to keep them in the container they arrived in. Just date it, and, if possible, label it with a list of contents.

This method is not amazingly satisfactory. Each time you need a particular picture, you have to sort through the individual containers till you find one which might contain the slide you are looking for. You then have to take out a batch of slides or prints. Finally, you can extract the one you need. Much better is to buy specially made containers.

For slides you can get cases. Each slide slots into its own position and any individual slide can be extracted without disturbing the others. The slots are numbered so that, provided you number the slides accordingly, every slide will have its own permanent position in its particular shot, you have to sort through the individual containers till you know that a slide indexed B73 for instance will come out of slot 73 in box B. A card index, listing all the slides and their positions in the various boxes will make your slide library complete. Rather than simply indexing your slides in chronological order of taking them, a

better idea might to be arrange them in alphabetical order of subject matter. This can raise its own slight problems later on, when you have to subdivide animals, say, into animals (domestic), animals (wild) and animals (zoo). However, it might be easier to do this than try to remember whether you took a picture fourteen years ago or seventeen.

Even more important is to have a good, safe system for filing negatives. Most of us, when we look at some delightful colour prints, tend to forget that these prints were made from negatives. If we need further prints or even enlargements, we are going to need these negatives in immaculate condition. It is important to remember that any marks, dirt or scratches which find their way on to a colour negative will be reproduced on every print or enlargement made from it in the future.

One of the easiest ways of storing negatives is to make use of a negative album – a book of envelopes for holding negatives. Each individual negative must be given a number which you mark on the bag it lives in and also on every print or enlargement you have made from it.

If you also have a print album in which you mount down each first time print, you will have a handy reference which you can flip through whenever you wish to locate a specific print or negative. Simply mark under each print the reference number which you have already given to the negative. Most negatives, nowadays, are returned from processing in strips and this makes them much easier to handle and store. Along the edge of each strip, every negative on the roll has its own number. You can make use of this number in your own system. For instance, supposing you have several negative albums, they can be labelled A, B, C etc. Next, every negative envelope will have a number. Finally, there is the negative number itself. Thus, if you locate a print which bears the code C-35-17 you'll know its negative is number 17 on the strip in envelope 35 in album C.

Viewing transparencies

Some ways of looking at transparencies are better than others. Simple hand viewers consist of just a magnifier and a slot for the

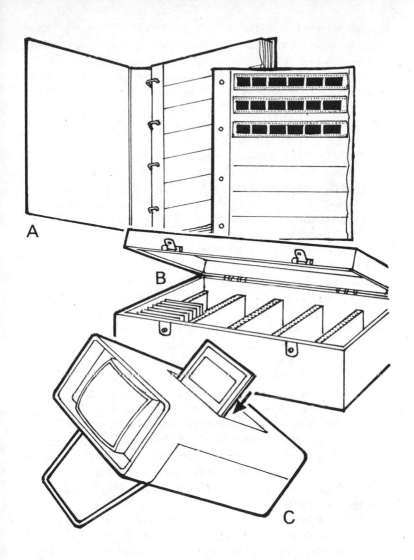

Protect the colour pictures you worked so hard to take. A. Keep colour negatives in an album (properly indexed, so that you can find them easily). B. Colour slides can be stored safely and neatly in an inexpensive slide box. C. A hand or table viewer is ideal for a preliminary inspection of your slides.

transparency to fit in. In fact, some 110 slides come in a box with a lid for this purpose. You simply hold the viewer up to a convenient light source and look at the picture, Unfortunately, only one person at a time can use them. Also, the light source used for viewing can be anything from a table lamp (which provides a very reddish light) to a cloudless, mid-summer-blue sky. Thus, you can build in a colour cast which, at the taking stage, you were careful to avoid.

The next stage on is the table viewer. This consists of a box with a large magnifier at one end and a built-in light source at the other. The slide slots in between the two. Usually, the light goes on as you push the slide in. A few people can see the picture at a time, and the picture may be bright and clear. Table viewers have the disadvantage that the image is usually somewhat distorted, and the light can be dull and reddish. It seems a shame to spend even a small amount of money on a camera which produces undistorted pictures, only to introduce distortion at the viewing stage.

By far the best method of viewing transparencies is to project them on to a screen. The advantages are that almost any number of people can view at the same time. Provided you buy a reasonably good projector, the image is sharp and distortion-free and the illumination the right colour. This shows your pictures to the very best advantage.

Projectors, like cameras, vary a great deal both in quality and price. They range from basic models to quite complex types. The most obvious difference between cheap and expensive projectors is in the method of feeding the slides. The more basic type have a "push-pull" slide carrier which holds two slides, one inside the unit, being projected, the other outside. When you push the carrier, it passes through the projector taking the slide which was outside, into the projection position. At the same time, the other slide is pushed out the other side of the projector. You then replace this with the next transparency you want to show.

Automatic projectors save this effort. Instead of loading each slide as you want to show it, you spend a little time beforehand loading a magazine. The magazine then fits on the projector. Each time you want to change to the next slide, you press a button. One good point about automatic projectors is that you can keep magazines loaded up permanently if you wish. You can make up selections of transparencies to form interesting programmes and keep them always ready for

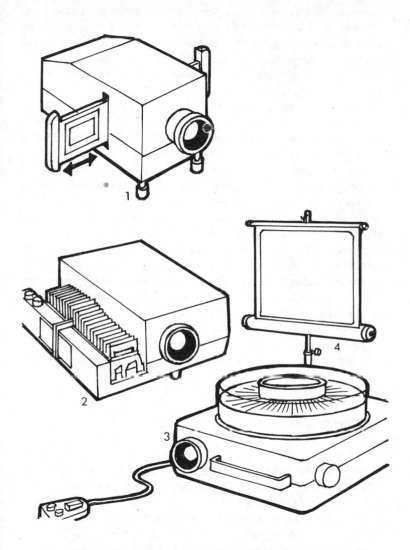

Slide projectors vary from simple hand-changed models (1) through button operated automatics (2) to sophisticated models with 80 or 120 slide trays and remote control of slide changing and focus (3). A good screen, (4) adds brilliance to your projected pictures.

showing. Extra magazines are usually readily available as accessories. A bad point, on the other hand, is that it is possible for slides to become jammed in the gate of the projector. The chance of this happening is less with a good quality machine. Jams can usually be cured fairly rapidly, but on odd occasions can cause serious damage to a slide.

More expensive projectors often have sockets so that you can plug in a remote control unit. You just press the button to change slides from your armchair. Alternatively, you may be able to link up a tape recorder and slide-tape synchronizer.

You need a screen to project your pictures on to. A flat matt-white wall in perfect condition is quite suitable if you have one. Otherwise there are three types of screens: matt white, (like the wall we have just spoken about), beaded and lenticular. Matt screens give the sharpest picture but the least bright one; beaded screens give the brightest picture but the least sharp one. Lenticular screens are something of a compromise, but cost rather more than either of the others. A disadvantage of beaded screens (and to some extent lenticular ones) is that they have a comparatively narrow picture angle. The picture gets rather dim if you get too far to either side of it.

Whatever type of screen you decide to buy, look after it carefully and avoid creasing it or marking the surface. It can be extremely difficult or even impossible to get dirt marks off the surface of a screen once they are on it.

Showing off your slides

As you gain experience and produce pictures which you feel are interesting and fun to look at, you will want to show them off to family and friends. A slide show is a good way of doing this and can make for a very enjoyable evening. However, there are some pitfalls which must be avoided at all costs if you want your friends to enjoy themselves and look forward to seeing more of your slides in the future. We have all been invited, at one time or another, to a slide show at a friend's home and groaned. Curtains are hastily drawn and we settle down to what seems an interminable barrage of slides — good, bad and indifferent; summer holiday mingling with winter

snow. It's no wonder the audience gets bored. How can you make sure that your show doesn't follow the same pattern? Simply by making sure you put on an exciting show with good slides. Try following these simple rules:

Only show your best pictures unless you have a good reason for doing otherwise. Nobody wants to see pictures which are unsharp, over-exposed or failures in any other way unless *they* have an interest in the subject matter. If you show only good pictures, people will look forward to seeing your slides and you will gain something of a reputation as a photographer. Keep your failures to yourself. A few good slides are much more enjoyable to look at than a lot of bad ones.

If you can, try to put your slides into some sort of order, or sequence — perhaps so that they tell a story. By doing so, you help to arouse and sustain the interest of the audience.

Make sure your pictures appear on the screen right way up and correct way round. There is nothing more embarrassing or frustrating than to have your best shot appear on the screen upsidedown. The trouble is, the whole show then comes to a stop while you fumble to take the picture out and put it back in the correct way. To prevent this problem arising, there is a standard procedure which all photographers adopt. As you look at your slide, right way up and right way round, mark a big spot, in a contrasting colour at the bottom left hand corner of the mount. If you then always insert your slides in the carrier with the spot in the top, right-hand corner, facing you, they will be correctly orien-tated on the screen.

Never leave a slide on the screen long enough for your audience to become bored with it. Give them sufficient time to appreciate it, then change to the next. Fifteen to thirty seconds is usually adequate un-less the picture provokes comment or conversation, in which case leave it on the screen until the conversation dies away. If you have a slide sequence (such as the leap-frog series we discussed on page 114), you can often generate excitement by adopting a snap-change technique. If you were showing this series of pictures, you might show the first for, perhaps, five seconds as a scene setter. Then, as quickly as you can, flash the others through leaving the last one on the screen for a while to enable the audience to get its breath back. A change of pace such as this is refreshing in the middle of a slide show and may draw some laughs, too. Don't overdo things though. Once

during the evening is enough, otherwise the trick loses impact.

For maximum picture brilliance, make sure the room is as dark as possible. Be particularly careful not to allow any stray light to fall on the screen, otherwise your pictures will look dull and degraded.

Think of your audience's eyes when you first switch on the projector and after you have shown the last slide. To avoid dazzling them, cut some pieces of card to the same shape, size and approximate thickness as your slide mounts. Have one of these in the gate of the projector at the start of your show and have one after the last slide. Alternatively use the completely black slides which, remember, we told you not to throw away. This way you avoid the glaring white of the screen appearing before or after your show.

By all means, chat to your audience briefly about the slide on the screen, preferably after they have had a few seconds to digest it. Avoid technical information, such as "this one was on uglichrome film and I gave $\frac{1}{125}$ second at $f8$ and had it processed by a little man I know, he never uses anything but trucolour chemicals". If a slide is worth projecting, it is because it is a good picture, don't steal its limelight — keep quiet!

Adding sound

Do you own a tape recorder? If you do, why not consider adding some music to your slide show. There's no doubt about it, some well chosen music can make an otherwise good performance superb. You can add commentary too. The big advantage is that if you have a set of slides which go well together and you tape music and commentary to go with them, you have a complete package which is permanently assembled and repeatable at any time.

Start off by preparing a script, so that you can record your commentary clearly and without hesitation, knowing exactly what you want to say. Keep the chat brief and to the point, with, perhaps, the occasional touch of humour. Remember what we said earlier about technical details and remaining silent where necessary.

Once you have selected your accompanying music, you are ready to record.

If you can, have somebody to help you and, unless you are an

enthusiastic audio man, take the easy way out and record commentary and music together. Your accomplice can help by changing the slides for you, so that you get the timing right. He can also control the volume of the music, raising it when you are not speaking and lowering it when you are. To avoid the noise of the projector being recorded, keep it as far away from the microphone as possible. Indicate on the tape the moment when you want a slide to be changed simply by tapping a pencil, once, on a table; this will provide the cue for you to go on to the next slide when you are presenting the show.

If the idea of a complete audio-visual presentation appeals to you, you can take it a good deal further. Hunt through your slides and select any which will fit together or even tell a story – it can be quite simple, but with appropriate music and, if necessary, commentary, you may find you have an interesting little documentary or playlet.

Better still, set yourself a project and go out and illustrate it. Choose a subject which appeals to you. For instance, you can put pictures to a piece of music which you enjoy, or you can take the most important feature of your town or village and link them together with music. You can have a lot of fun preparing your own slide-tape packages and you will find it gives a completely new slant to your photography. Instead of taking one picture because it pleases you, you start to think in terms of sets of pictures. In effect, you become a producer (as well as director, camera-man, and sound recordist). Why not try it. You can be certain your audience will enjoy the results as much as you enjoyed preparing them.

Showing your colour prints

One of the most compact and attractive methods of showing your colour prints is to mount them into albums. An album protects the prints inside it and keeps them together and in order. It also supplies a good background and makes it easier for people to look at them.

It is a good idea to make up your own albums. You can do this cheaply and easily and to your own specification. Use the ring binders (which are available from most stationers,) and grey cartridge paper for the pages (black is rather funeral and white detracts from the brilliance of the colours). Cut the pages neatly to size and punch holes for the

rings. A good point about this idea is that you can add, subtract or change the order of pages just as you wish. The easiest method of mounting the prints is to use photographic mounting adhesive – your photographic dealer will supply you with this. Alternatively, you can get mounting corners – transparent ones hardly show at all on glossy prints.

Don't just stick prints down willy-nilly; try instead to design the pages of your album so you achieve the best possible presentation. A few pictures attractively arranged on a page look far better than the same page crammed with prints. If you normally have en-prints made, then set a maximum of three per A-4 size page (8 $\frac{1}{4}$ × 1 1$\frac{3}{4}$ inches). Add captions, where necessary, giving the date and location and perhaps also the names of people you might otherwise forget. If you make up albums in this way, you can afford to have different albums for different subjects – Holidays 1976; Unusual Inn Signs; Liverpool After Dark and so on. Albums like this make much more interesting and unusual talking points than the more conventional "coffee table" books and, at the same time, show people how talented you are with a camera.

Of course, you aren't going to be content with small prints for long. Sooner or later you are going to want enlargments and this is where you will get a big surprise. Suddenly from tiny, colourful snapshots, you have real pictures, pictures with warmth, depth and far more impact and richness of colour than you would have dreamed possible. If you doubt this, select your favourite picture and have an enlargement made from it. Make sure it is sharp and that there are no defects such as scratches, or dirt on the negative.

Unfortunately, the more you increase the size of the picture, the more you also magnify its shortcomings. This is the reason why you must keep your negatives carefully stored away and in pristine condition. One tip: when you are selecting your picture for enlargement, look at it carefully and decide whether it could be improved by cropping, that is, cutting out any unwanted areas at the edges of the picture. If, for instance, you have a shot showing the Eiffel Tower on a square negative, you have a lot of unwanted space at the side. If you cut these unwanted areas out, you end up with a much more dramatic upright picture. When you give the negative to the dealer for enlarging ask him to do this for you. It helps if you give him written instructions,

A. The correct way to spot slides: mark the bottom left-hand corner when the picture is right way up and the right way round. B. A good way of marking slides in a sequence. Using this method makes it easy to spot any which are out of sequence, missing transparencies or even intruders. C. Use two-L-shaped cards to help you decide whether your prints could be improved by careful cropping.

and possibly a diagram, specifying exactly what you want. This ensures the wrong areas are not cut off your picture.

Many excellent photographers are delighted with their pictures, have big enlargements made — and then put them away; carefully, of course. What a shame. They are missing a golden opportunity for showing off their pictures and decorating their homes at the same time. When you have your enlargements made, try to use them. There are many ways you can show them off to advantage. The simplest way is to buy a frame. Make sure you keep it simple, though. The last thing a bright, brash colour picture needs is an ornate, gold frame. There are many do-it-yourself picture-framing kits on the market at the moment and these mainly consist of simple, black, grey or white square, plastic frames. These are ideal for your pictures for they attract little attention to themselves. They retire into the background while your picture gains all the praise. If your frame has glass on it, create a slight separation between glass and print by inserting some pieces of card or other spacing material at the edges of the frame on all four sides. This prevents glass and frame sticking together and giving rise to unwanted patchy areas.

Before you frame your print, it is a good idea to mount it on to heavy board. This strengthens and protects it. Choose a good-quality, grey art board and mount the print with mounting paste or dry-mounting tissue. Dry mounting is not a difficult process provided you follow the instructions packed with the tissues. However, one piece of advice may help you. Always ensure that both the mounting board and the print are perfectly dry. If either is the least bit damp you will have problems. Be particularly careful with resin-coated papers, however. These papers (which include almost all modern colour papers) are damaged by temperatures above 93° C. You must never exceed this temperature.

If you would like to give your pictures a modern look and, at the same time, dispense with the need for frames, why not try flush-mounting your pictures for hanging on the wall. You still need to mount them on heavy board, but this time you cut off any overlap using a *very* sharp knife and a steel straight-edge. If the prints are fairly big, you may find that the mounting board tends to curl a little. A waste print mounted on the back will help to hold it flat, or you can mount the whole thing, yet again, on to a piece of hardboard cut to the right size.

A. Dry mounting can be done with a domestic iron. (1) Tack the tissue to the back of the print. (2) Trim print and tissue together. (3) Place the print in position on the mount (lift the corners of the print and tack the tissue to the mount) and cover it with dry cartridge paper. (4) Apply the iron evenly over the whole area of the print. B. (1) A dry mounting press is almost essential for mounting resin coated papers (most colour prints) because the temperature *must* be accurate. (2) A tacking iron makes the process easier.

One word of caution, the dyes used for normal colour prints are not especially light-resistant. If you put your pictures in the sun, they will soon fade — like the pictures in an estate agent's window. So, keep your print displays confined to the shadier corners of your house. If you do need a picture to remain unfaded in the sun, consult your dealer about having a special print made. Both Dye Transfer and dye destruction prints are much more fade-resistant, but very much more expensive.

Greetings cards

Christmas or birthday greetings cards are made a little more personal with a colour print. Most photographic retailers stock greetings cards into which you can slip a colour print of the correct size and shape — all you have to do is select the card you like and choose the print you want to insert. Processing houses may have special promotions at Christmas whereby if you have a certain number of colour prints made, they will give you that number of Christmas cards, free. This can be a good way of saving money. Alternatively, going completely the other way, you can have your own cards printed, with a space in which to stick the photograph. Of course, if you are the slightest bit handy with pen, brush or rub-down lettering, you might prefer to make your own cards from scratch. Family pictures and photographs of the children are most popular for making up greetings cards, but you might want to be a little more individual and take your pictures specially for the occasion. For instance, in January or February when the first snow falls, grab your camera and get out while the going is good. It may seem early, but it is the best chance you have of getting seasonal pictures for next Christmas.

Slides into prints and prints into slides

A point which is worth bearing in mind when it comes to showing off your pictures is that you can have colour slides made from your negatives and colour prints made from your transparencies. Thus, you are not tied irrevocably to any one medium.

If you have a particularly good transparency why not have a colour enlargement made from it. You can then frame or mount it, using one of the methods discussed above, and display it all the time. There are two commercially used methods of making prints or enlargements from transparencies. The first is called the reversal method, and uses the same photographic technique to produce a print as was used to give you the original transparency. This method is reasonably in-expensive, but can lead to some loss of quality – your print may not be quite as brilliant or as colourful as your slide.

The second method will produce prints which are much more like those from negatives. It is called the internegative method, and, as you might guess, involves making a negative from your transparency and printing from that. If your transparency is not quite up to scratch in colour or density, this is the method to specify, for it offers scope for some improvement in quality. It will not help transparencies which are unsharp, or marked or stained in any way, though. Again, as might be expected, because there is an intermediate stage – the making of the negative – this method is much more expensive than the reversal process.

Similarly, you can have slides made from your colour negatives. This is a fairly simple process and can usually be relied on to give you results of, at least, comparable quality to the prints you already have. Thus, if you have a gap in one of your slide shows, have a look through your collection of prints. You may be able to fill it by having a transparency made.

Perhaps it is worth mentioning, at this point, that you can also have duplicate slides made from your transparencies. One of the problems with colour slides is that they are a "one-off" system – that transparency which you are constantly handling, viewing or projec-ting is a precious original. If you cherish any one particular, irreplaceable slide, you might consider having a duplicate made from it, which you can use freely, while the original is kept safely stored. Quality can sometimes suffer slightly, however, in the copy.

Camera clubs

One thought which applies equally to the photographer who produces prints, or the photographer who makes colour slides. A

good way of showing off your pictures to a receptive audience and, at the same time, gathering useful criticism and helpful advice, is to join a camera club. Photographic societies exist all over the country and many of the larger towns boast two or three. If you decide to join one of these clubs you will be sure of a welcome and you will find that your photography will advance far more rapidly than might otherwise be the case. You also gain the opportunity to enter club-organised competitions and exhibitions, which tends to put you a little more on your mettle and try just that little bit harder. You are almost certain to find details of meetings in your local newspaper. Think about joining one.

When
Things
Go Wrong

Unfortunately, it can happen to the best of us. Things can go wrong, mistakes can be made and we find we have a failure on our hands. More often than not, the fault is ours. Modern colour materials are manufactured under extremely rigorously-controlled conditions and it is rare for a fault to be directly traceable to a defective film. Where the film itself is proved to be faulty, the trouble is usually found to have been caused *after* the material left the manufacturer.

Poor storage can cause problems. Heat and damp can alter the colors both before and after exposure. To leave a colour film for any length of time on the parcel shelf of a car, for instance, is asking for trouble — particularly if the weather is hot and sunny. If you buy film in any quantity, or, perhaps, have it given to you and you know you are not going to use it immediately, then store it in a cool, dry place. Better still keep it in a refrigerator. If you do store film in a refrigerator, however, take it out a few hours before you want to open it. This lets it reach room temperature. If you open it cold, you may get condensation forming on the surface of the film.

Once you have exposed a complete cassette or cartridge of film, have it processed just as soon as you can. Leaving film lying around does nothing at all to improve its colour quality. If you must keep it, wrap it up, and keep it cool and dry.

Normally, we don't realize we have problems until we see the results of our efforts. Then it's usually too late to improve matters. However, it is nice to be able to recognise the cause of the trouble so that we can ensure it doesn't happen again.

This chapter lists some of the most likely faults in colour slides or prints. It also tells you what may have caused them in your pictures. Here's hoping you never meet up with them.

Picture too dark

A print or transparency too dark all over, with muddy colours and detail-less shadows, was probably under-exposed. To get top quality pictures, you need really accurate exposures. Colour negative films do have a reasonable amount of exposure latitude. 1 stop under-exposure or 2 stops over-exposure don't make too much difference to your picture. The same is not true, however, for reversal films. When

you are taking colour slides be especially careful to get the exposure right.

If you only have the occasional under-exposed slide or print they were probably just accidents. Perhaps you mis-read the exposure meter or set the wrong aperture. However, if a whole reel is under-exposed, then it is more likely that you didn't set the correct film speed on the meter. If you set the film speed too high, your pictures come out under-exposed. So, you must check that the film speed is set right every time you load a film. If you get the speed right, and your films are still consistently under-exposed, there could be something wrong with your camera. It may be worth having it checked. It is possible that the shutter, or even the diaphragm, is not working properly. If your exposure meter has a battery, don't forget to make sure that that, too is o.k. Be very careful when taking a meter reading that it is the *subject* brightness you measure. It is very easy, when out of doors, to allow the sky, or other very bright areas, to influence the exposure meter which will give a false over-optimistic reading.

If you have dull muddy colourprints, have a look at the negatives. They may just have been badly printed. This is probably so if the negatives are reasonably dense. If on the other hand, they are just about the same orange-brown all over, with faint ghosts of a subject, and perhaps a few strong bluish dots, they are the culprits. They were under-exposed. The orange masking on colour makes them a bit tricky to assess; but you can compare a suspect negative with one which has yielded a perfect print. If the two negatives are similar in density it is likely that one has just been badly printed. Ask your dealer for a reprint.

Picture too light

A picture which is too light, with pale, de-saturated colours and little density in the shadows or dark areas has all the symptoms of *over* exposure. Just as with under-exposure, you may have set the film speed or camera controls incorrectly.

Again, if your pictures are consistently too light, have your exposure-meter battery or your camera checked. Poor printing technique can also cause colour prints to look too pale. An over-exposed negative

looks heavy and dense compared with a properly exposed one. If you have any doubts, ask your dealer's advice. He should be able to help you.

Picture unsharp

Pictures can be unsharp for a variety of reasons. Look at your negatives or transparencies closely, preferably using a magnifier. Don't go solely on the appearance of prints; they can be unsharp for other reasons. If a negative appears to be sharp but the corresponding print unsharp, then ask your dealer if it can be reprinted.

Focusing

Most unsharpness comes from incorrect focusing. Have a look at the picture and see if there is any part of it which is sharp. For instance, if the young lady in the foreground, whom you were photographing, is unsharp and yet the trees behind her are sharp, you probably forgot to focus the camera lens. However, if all your pictures are blurred, perhaps there is something wrong with your camera. You can check your focusing fairly easily by running a black and white film through the camera. Pay special attention to focusing, preferably measuring distance with a tape measure. Use as wide an aperture as possible so that depth of field does not mask any defect. If the accurately focused camera does give you blurred pictures, have it checked by your dealer.

Camera Shake

Blurred pictures can be caused by camera movement. Look at your colour negative, or transparency, through a magnifying glass. You may see one, fairly clear, sharp image possibly surrounded by one or more other sharp images (of the same subject); these images may be joined together by streaking. This is the result of camera shake. If camera shake spoils your pictures, you have two possible courses of action open to you. You can find what is the minimum shutter speed at which

you always get sharp results, or you can make a practice of using a camera support.

To test the shutter speeds, load up a black-and-white film, and take several pictures at each shutter speed. For instance, if the exposure indicated by the meter is $^1/_{125}$ at f5.6 then, assuming you have a 36 exposure film, take six pictures at each of the following settings $^1/_{500}$ at f2.8, $^1/_{250}$ at f4, $^1/_{125}$ at f5.6, $^1/_{60}$ at f8, $^1/_{30}$ at f11 and $^1/_{15}$ at f16. Choose a subject with plenty of contrast with horizontal and vertical lines which show up any camera movement. Perhaps you could choose a modern multi-storey office block with plenty of windows. Make sure that you focus accurately.

When you get your negatives back from processing, either mount them up in 35mm slide mounts and project them, or you can look at them through a high-powered magnifier. Make sure, though, that you look for the characteristic double image of camera-shake. It will probably turn up around $^1/_{60}$ or $^1/_{30}$ second. (However, if you are really steady you may be able to hand-hold $^1/_{15}$ second.) Let's assume you can detect movement at $^1/_{30}$ second; from now on you should never try to hand-hold at less than $^1/_{60}$ second unless it is absolutely unavoidable.

One further point, if you have interchangeable lenses, remember that the image *movement* is magnified just as much as its size. So if you can hand-hold just at $^1/_{30}$ second with your standard (say 50 mm) lens, you need to use at least $^1/_{60}$ second with a lens of double the focal length (100 mm). Conversely if you use a very wide angle lens (say 24 mm) you should be able to get sharp pictures at $^1/_{15}$ second. To use a support, such as a tripod, at all times irrespective of what shutter speed you employ is somewhat limiting. You can't do any snapshot or candid work. A much better decision would be to use the method outlined and find out which shutter speeds you *can* safely hand-hold at.

Check on the lens

You can get unsharp pictures because of dirt or condensation on the lens. These two faults also have another effect; you get poor contrast and desaturated colours – rather as if you had taken the pictures

through a haze (which, indeed, you had). Always make sure your lens is clean. Buy a good lens cleaning brush and use it *only* when you have to. Lenses should be looked after carefully and *prevented* from getting dirty rather than cleaned regularly. They are usually made of soft glass, or plastic. Most are coated with not-too-tough anti-reflection material, which can also be damaged. So they can easily be scratched or marked, and once this happens, good definition is gone for ever.

You get condensation on lenses for the same reason that it occurs on windows. The lens is colder than the air around. If you take your camera indoors where it is warm after being outside on a cold day, it will get steamed up. If you can, wait until this misting disappears before you attempt to take any pictures. If you are in a desperate hurry, clean the lens, gently, using a clean, lint-free cloth. *Don't* rub hard. Remember, however, that there may well be condensation on the inaccessible inner surfaces.

Condensation on the surface of the film can also ruin your pictures. This is only likely if you take it out of a deep-freeze, or refrigerator, and put it straight into the camera. Always let a film warm up for about two hours after taking it out of cold storage.

Picture too yellow

There are two possible reasons why colour prints or transparencies should be too yellow. The first, and most likely, reason is that daylight material was used under artificial lighting conditions (not fluorescent lighting, though) without a suitable converson filter. Always make sure that you have the right material for the job in hand, or, second best, a filter to convert the film to the required colour balance. If you have a transparency which is too yellow, little can be done to improve it. However, if a print is too yellow, for the reason just given although nothing can be done to improve that particular print, it should be possible to have a better one made. Explain to your dealer that the picture was made under artificial lighting and you would like this to be compensated for during printing (he will need the negative, of course).

The second possibility is that the picture was taken with the right film,

but with an inappropriate filter accidentally left on the lens. This might happen if you had previously used an artificial-light film in daylight, or a black-and-white film with a "cloud filter". If you made this sort of mistake, you probably expected your off-colour slides, when you noticed the filter in position and removed it. Whenever you use filters of any sort over the lens, make sure you remove them as soon as you have taken your picture (haze filters are an exception to this rule — they can be left in position permanently as an added protection for the lens).

Picture too orange

The most likely reason for an overall orange or red cast in your picture is that it was taken too late in the day, or possibly too early.
Around sunrise and, more usually, sunset, the light becomes much more red in quality and, although we tend not to notice this at the time, it shows up clearly in pictures. Unless you wish to actually show the sunrise or sunset in your picture, it is better to avoid taking colour photographs about an hour before or an hour after sunset or sunrise. Because the sun is so low in the sky, winter sunshine can often be much more orange in colour than you would expect. It pays to look for this before you take your picture.

Picture too blue

Transparencies which are much too blue are normally the results of using artificial light film in daylight without the necessary conversion filter over the lens. This is rather more likely to happen than the other way about because one is more used to having daylight type film in one's camera than artificial-light film. If you think your memory is likely to let you down, tear off the end of the film box which has the identification code of the film printed on it and tape it to the back of the camera. This is a sure reminder for you.
Another source of blue light is the sky. On sunny days, things in the shade are lit only by the blue sky and, of course, they aquire a blue cast. This is especially obvious if you take pictures in the snow. All the

shadows come out blue. You need to use a suitable filter even with daylight film if you want to correct the colour on pictures taken in the shade.

Another possiblity, of course, is that you were using daylight film in daylight but had forgotten to remove the blue conversion filter from the lens. This might happen if you had previously been using the same film in artificial lighting. As we said above, *always* make it a rule to remove special screens or filters from the lens after using them.

Pictures too green

You get rather green pictures on daylight film, with some fluorescent lighting. Unless you know the type of fluorescent lighting in use, it is impossible to compensate exactly for it with filters. However, generally, you should get an acceptable result on daylight film if you use a medium-magenta (blue-pink) filter over the lens, increasing the exposure accordingly. A filter such as a Kodak CC Filter 30 M gives good results when used with cool white fluorescent tubes. You will need to increase exposure by $2/3$ stop when using this filter. Alternatively, one or two manufacturers supply special filters to compensate for fluorescent lighting.

If you have to take important pictures under this type of lighting, load your camera with negative film and then use the most suitable correction filter. You can then have transparencies made from the negatives and the colour can be corrected, to a great extent, at that stage.

Unusual overall colour casts on some pictures only

This can be caused by taking pictures in unusual lighting conditions, through coloured windows or through unusual filters. Usually, you can recognise the situations, but if you can't the thing to do is think back and work out what the prevailing conditions were, what sort of subject you were taking and whether or not you were trying to achieve any special effects (even on earlier pictures, for you may have forgotten to remove a filter).

A. If you think you might forget, use the carton end as a film reminder.
B. Loading a 35mm camera: (1) Open camera back. (2) Pull out rewind knob. (3) Insert cassette. (4) Push back knob. (5) Insert film into take-up spool and wind on once. Use rewind knob to take up slack. (6) Close back. (7) Wind on to first frame. Check that rewind knob is turning.

Unusual colour cast over the whole length of film

Colour casts on your pictures can sometimes be caused by faulty processing. If every slide or print from a particular length of film shows the same overall colouration, then have a word with the dealer who handles your processing. Alternatively, if you send direct to the film company for processing, write to them, including the pictures saying that you believe processing was at fault.

It is not very likely that anything can be done to improve your pictures (although there is more possibility of this happening with colour negative films than colour transparency films because correction may be possible during re-printing), however, you may, at least, be recompensed. Beware, though; make sure that the film you used was not outdated stock or badly stored before or after processing. This can give rise to all sorts of problems of exposure and colour. Always use fresh film and always store it carefully.

Small localized areas of unusual colour

These sorts of colour casts are usually due to a coloured reflecting surface, possibly outside the picture area. For instance in a green-painted room a subject will be coloured somewhat green by light reflected from a nearby wall. Even a bright-yellow sweater can make a girl look rather yellow around the neck and chin. In general, colour casts which obviously have a reason — such as the girl's sweater — are less objectionable than colour casts caused by objects outside the picture area — such as the green wall.

If you look at your subject, carefully, before you take a picture, you will see any colour casts and what is causing them. You can then decide whether they are objectionable or not and whether you should do something about them.

Film completely unexposed

Unexposed transparency film is completely black after processing. Negative film is an even blank orange-brown. The most likely cause is

that you sent an unexposed film for processing. Alternatively, with 35 mm film, you may not have attached the leader correctly to the take-up spool when you loaded it. Always make a point of checking that the film is winding on properly before you close the camera back and then check that the rewind knob turns every time you wind on the film. Don't forget, too, to take up the slack in the cassette by gently winding the rewind knob until you feel tension.

You can get blank films because of a camera fault. Check the shutter by opening the camera back (when the camera is unloaded) and watching as you release the shutter.

Flash pictures blank or only partially exposed

This is almost certainly due to using the wrong sychronization setting or to using the wrong shutter speed with that setting. Always use X-synchronization with electronic flash, or with flashbulbs at *up to* $1/60$ second. Use M-sychronization with flashbulbs at any shutter speed (but remember to adjust the guide number accordingly). Use focal-plane shutters *only* at the recommended shutter speed or, if none is recommended, no faster than $1/30$ second.

In conclusion

If you're just starting, don't let this catalogue of disasters put you off. No doubt things will go wrong sometimes, but not as often as you might imagine. When you get failures, look at them and work out what went wrong. Try to remember what you did at the time you took it. Soon you'll be conscious of the right things to do each time you press the button. If you really take a lot of pictures, most of the technical operations will become second nature.

Then you can concentrate on the really important part of colour photography (and black-and-white photography for that matter) — composing good pictures. So don't worry too much about the mechanics, just make pictures.

Index